STEAM AROUND BRISTOL

The Final Years

Patrick O'Brien & David Nicholas

AMBERLEY

The last regular steam-hauled diagram in the Bristol area was the local service between Bristol Temple Meads and Bath Green Park, routed on the Midland line via Mangotsfield. The service lasted until the closure of the Somerset & Dorset joint line from Bath Green Park to Bournemouth on 7 March 1966, when the intermediate stations from Bristol to Bath Green Park were closed. This local service remained steam hauled until the last official day of steam on the Western Region, Saturday 1 January 1966. The cover illustrations show Up and Down workings, each with the Swindon-built standard 3MT tanks, favoured at the end.

Front cover:
No. 82044 leaves Mangotsfield with 2B93 10.10 a.m. from Bath Green Park to Bristol Temple Meads on Saturday 16 October 1965. This loco was withdrawn from Gloucester (Horton Road) shed during the previous August and reinstated for a few months at Bath.

Back cover:
On the same day No. 82030 enters Staple Hill with 2B93 1.30 p.m. Bristol to Bath Green Park. As with No. 82044, this loco had also been withdrawn from Gloucester earlier in the year and reinstated at Bath until the end of December 1965, when steam ceased on the Western Region.

First published 2016

Amberley Publishing
The Hill, Stroud
Gloucestershire, GL5 4EP

www.amberley-books.com

Copyright © Patrick O'Brien & David Nicholas, 2016

The right of Patrick O'Brien & David Nicholas to be identified as the Authors
of this work has been asserted in accordance with the
Copyrights, Designs and Patents Act 1988.

British Library Cataloguing in Publication Data.
A catalogue record for this book is available from the British Library.

ISBN 978 1 4456 5488 1 (print)
ISBN 978 1 4456 5489 8 (ebook)

Typeset in 10.5pt on 13pt Sabon.
Typesetting and Origination by Amberley Publishing.
Printed in the UK.

Introduction

When Bristol's last steam shed closed in November 1965, it was the final chapter in the elimination of steam from the Bristol area in a process that had taken over seven years. Although diesel multiple units had been introduced on some local services in the late 1950s, the departure of Castle Class No. 5085 *Evesham Abbey* on the final Up steam-hauled Bristolian on 12 June 1959 signalled the beginning of the end for steam on express trains in Bristol. Workings to London and the West Country were gradually dieselised over the next two years, leaving only trains to the Midlands and North East, North West via Shrewsbury and on the secondary lines to Cardiff, Weymouth and Salisbury still rostered for steam power. The closure of Bath Road shed in September 1960 for rebuilding as a major diesel depot and the increased pace of diesel-unit deliveries were early indications of the Western Region's intent to eliminate steam from the area.

The arrival of Peak D93 for crew training in the spring of 1961 also heralded the impending replacement of steam power on the important route from Bristol to Birmingham, Sheffield, Leeds and Newcastle. By September of that year, six of Bristol Barrow Road's Jubilees had been transferred away and all express trains on the route were scheduled for diesel haulage. Some of the more important freights on the line were also dieselised in November and then, curiously, there was a period of over two years before final dieselisation of the remaining freight traffic took place. The first trains north of Bristol via Shrewsbury went over to diesel haulage in January 1962, with the remainder following six months later. The exercise had been implemented too quickly, however, and four trains reverted to steam haulage for over two months in spring 1963.

On Summer Saturdays, however, virtually all extra passenger trains were rostered for steam up until 1964 on most routes but, in 1965, steam only appeared on the extra holiday trains from Wolverhampton and return. St Philip's Marsh shed closed in mid-June 1964 and Barrow Road became responsible for all steam workings for the last eighteen months, before its closure on 20 November 1965. By that time the daily number of steam workings had been reduced to less than twenty-five. Line closures and rationalisation also contributed to the decline of steam, with local trains to Portishead, Gloucester and Wells being withdrawn, and the closure and run down of freight yards such

as Westerleigh and St Philip's. Steam continued for a while after the closure of Barrow Road, with a few locals from Bath Green Park still steam-hauled and Standard 3 tank No. 82041 performed the final steam duty from Temple Meads on 1 January 1966. Occasional steam visitors from the Midlands continued until the spring of that year.

It was the ever-quickening pace of the transition that stirred the co-authors to record and photograph the rapidly changing scene. Those records and photographs, mainly unpublished for fifty years, now form the basis of this book, which hopefully will give the reader an insight into the railway workings in Bristol in the early 1960s. Photographs in this book are by David Nicholas, unless otherwise attributed. Particular thanks must also go to Steve Montgomery, whose patience, skill and expertise have produced quality images from fifty-year-old negatives.

David Nicholas and Patrick O'Brien

Reporting Numbers

The first digit (or headlamp arrangement with steam locomotives) indicated the type of train.

The second digit indicated the destination of the train, and the third and fourth digits the train itself. For example:

1B04 8.45 a.m. Paddington–Bristol (express passenger)
4N18 2.55 p.m. Bristol St Philip's Yard–York (express freight with not less than 50 per cent of vehicles continuously vacuum-brake to engine, pipe-fitted

1		Express Passenger or Newspaper train
2		Local or Stopping Passenger train
3		Parcels train
4		Express freight with not less than 50 per cent of vehicles pipe-fitted to the engine
5		Express freight with not less than 33 per cent of vehicles pipe-fitted to the engine
6		Express freight with at least four vehicles pipe-fitted to the engine
7		Express freight not fitted with continuous brake

8		Through freight
9		Mineral or empty wagon train
10		Pick-up branch freight, mineral or ballast train
11		Light engine with not more than two brake vans

A	London
B	Bristol area
C	South West
E	Eastern Region (e.g., Sheffield)
F	Swansea area
H	Gloucester and Worcester
M	Midland region (e.g., Birmingham)
N	North Eastern region (e.g., Newcastle, Leeds)
O	Southern region (e.g., Salisbury, Portsmouth)
T	Cardiff area
V	Trains to Western region originating from another region
X/Z	Special trains

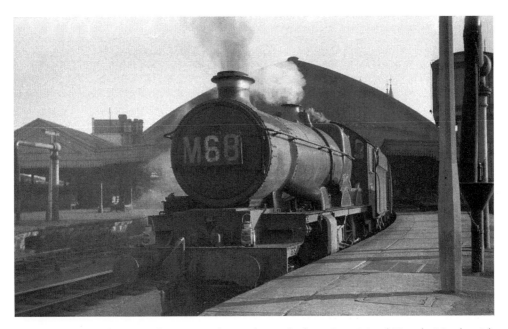

No. 4080 *Powderham Castle* waits to depart from Platform 9 at Bristol Temple Meads with 1M99 12.00 p.m. Penzance–Liverpool (with through coaches to Glasgow) on Thursday 8 June 1961. The engine is displaying the headcode for an earlier working from Cardiff to Shrewsbury before working back to Bristol and finally taking out this train at 7.15 p.m.

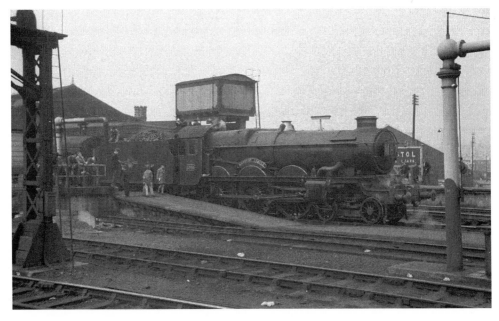

On Saturday 29 April 1961, No. 5095 *Barbury Castle*, allocated to Shrewsbury, takes water on Platform 7 at Bristol Temple Meads with the through working from Newton Abbot to Shrewsbury on 1M87 8.00 a.m. Plymouth–Crewe. The train remained steam worked until March 1962 and No. 5095 was withdrawn in August the same year.

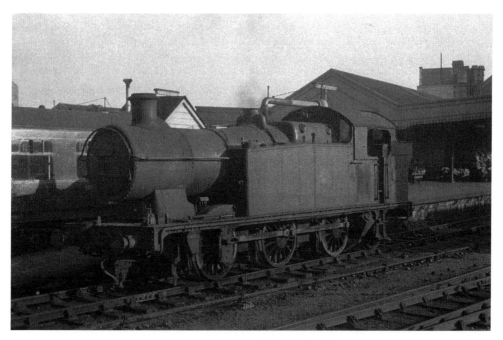

Collett 0-6-2T No. 6681 pauses light engine at the end of Platform 7 at Bristol Temple Meads on Monday 19 June 1961. Although the class was mainly associated with coal traffic in South Wales, a few were allocated to Bristol until September 1962. A number, including No. 6681, were outshopped in lined green livery.

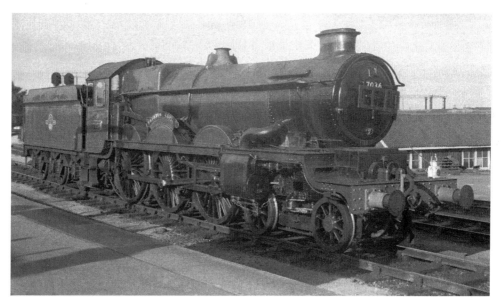

On Monday 19 June 1961, waiting for the signal to go to collect stock from Dr Day's Sidings, No. 7036 *Taunton Castle* is resplendent in ex-works condition, having been released from Swindon Works a few days earlier. It was common practice to run in ex-works locos on stopping trains to Didcot and Bristol.

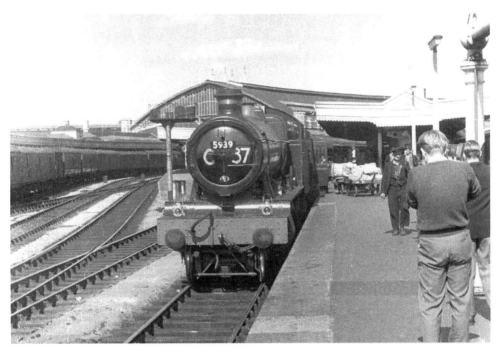

Ex-works No. 5939 *Tangley Hall* waits to come off 1C37 10.10 a.m. Wolverhampton to Penzance at Platform 5 at Temple Meads on Saturday 9 September 1961.

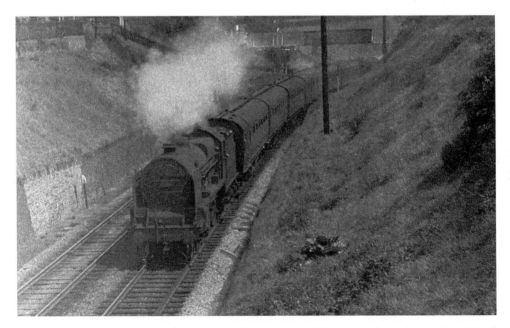

Patriot No. 45504 *Royal Signals* (82E) is on the last stage of its journey from the north to Bristol as it heads through Staple Hill in May 1961. With six of Barrow Road's Jubilees transferred to Shrewsbury in September 1961, Bristol's three Patriots, Nos 45504/06/19, were kept busy; however, in March 1962, they were summoned to Crewe Works for withdrawal and scrapping.

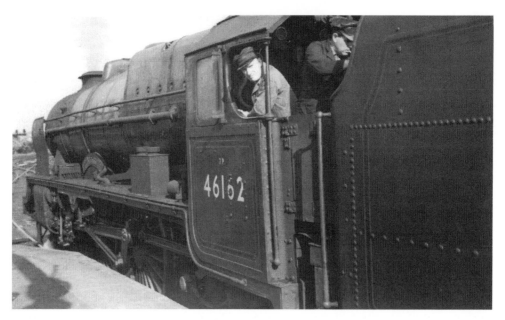

The driver of Royal Scot 4-6-0 No. 46162 *Queen's Westminster Rifleman* waits for the off with 1N87 11.00 a.m. Newquay–York at Platform 9 at Temple Meads on Saturday 26 August 1961.

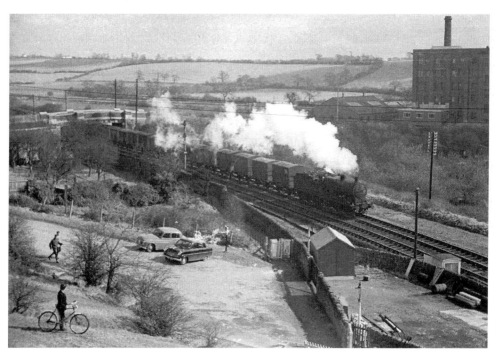

An unidentified ex-LMS 4F 0-6-0 approaches Mangotsfield station with a transfer freight from Westerleigh Yard in the early sixties. Carsons Chocolate factory can be seen in the background, while a Ford Consul and Rover 90 are visible in the foreground. Housing now occupies the site of the former factory.

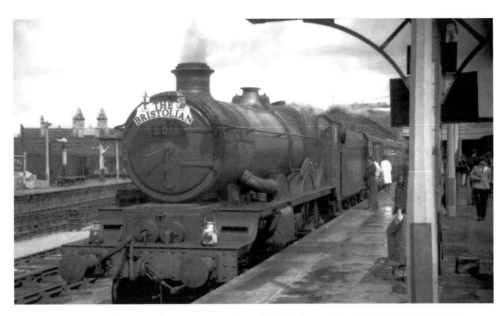

The Summer Saturday 'Bristolian' waits at the end of Platform 5, hauled by No. 5015 *Kingswear Castle* on Saturday 21 July 1962. Although dieselised in June 1959 and running from Monday to Fridays only, in 1962 Old Oak Common supplied Castles and Kings for the Saturday 1B04 8.45 a.m. Paddington–Weston train, complete with headboard, returning on the 2.35 p.m. Weston–Paddington.

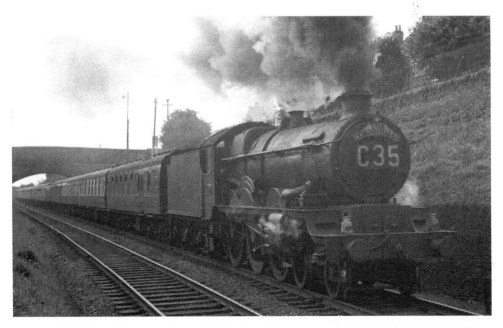

No. 5008 *Raglan Castle* storms through Staple Hill station with the northbound *Cornishman* 1H32 10.30 a.m. Penzance–Wolverhampton on Friday 17 August 1962. The engine still bears the reporting number for the southbound working earlier in the day. Within weeks, at the end of the summer service, the engine was withdrawn and the train re-routed to Sheffield and dieselised.

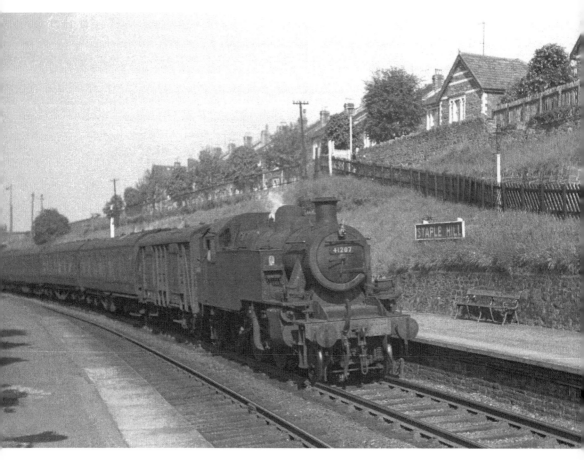

Ivatt 2-6-2 tank No. 41207 (82E) calls at Staple Hill with 2B92 9.03 a.m. Bristol–Bournemouth West on Friday 1 June 1962. These engines were in common use on local trains to Bath Green Park until early 1964, when Standard Class 3 tanks prevailed.

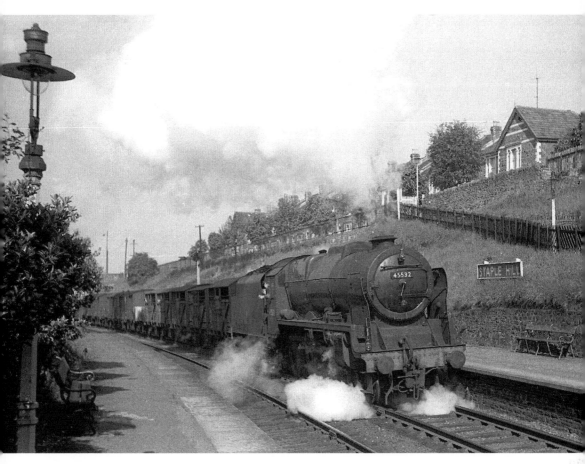

Rebuilt Patriot No. 45532 *Illustrious* pounds through Staple Hill with 5M19 8.50 a.m. St Philip's Yard–Water Orton on Friday 1 June 1962. Although Royal Scots and Rebuilt Patriots were common visitors to Bristol in 1961/2, they would soon be transferred away or withdrawn, and become relatively rare.

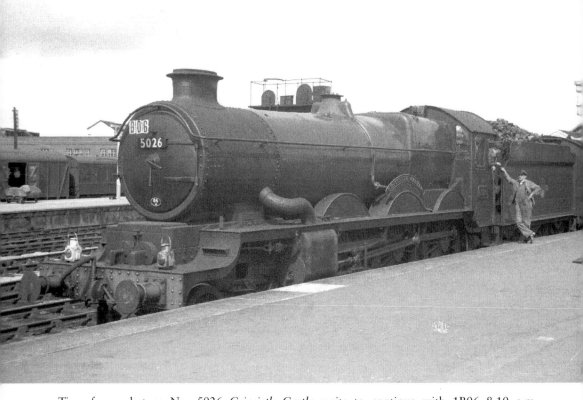

Time for a chat as No. 5026 *Criccieth Castle* waits to continue with 1B06 8.10 a.m. Wolverhampton–Weston at Platform 5 at Bristol Temple Meads on Saturday 18 August 1962. The Summer Saturday trains from Wolverhampton to the West Country remained steam hauled as far as Bristol until 1965.

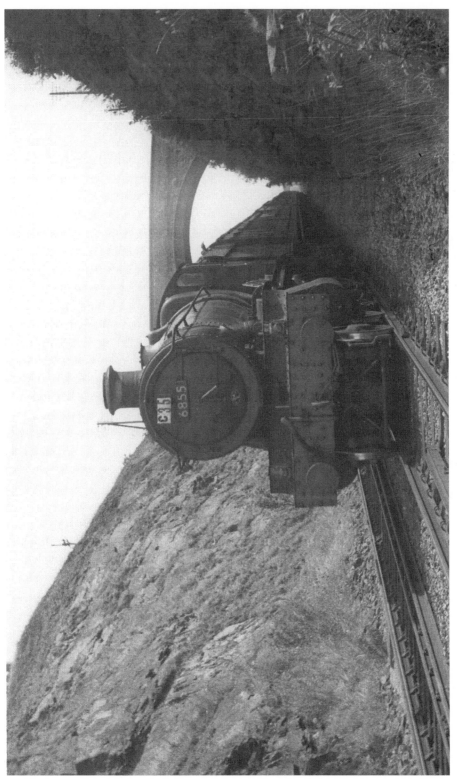

On Saturday 1 September 1962, No. 6855 *Saighton Grange* hurries through Winterbourne with 1C35 9.10 a.m. Birmingham (Snow Hill)–Paignton. Note the Automatic Warning System (AWS) ramp on the track to help drivers observe and obey signals.

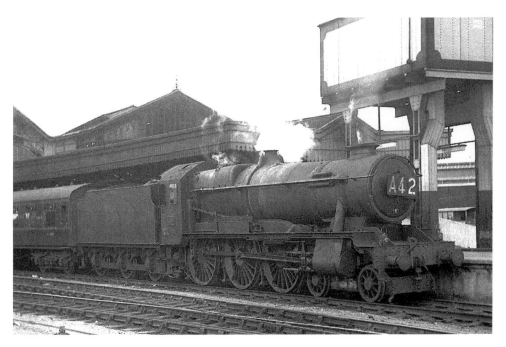

No. 1009 *County of Carmarthen* (82B) waits to depart from Bristol Temple Meads with 1A42 10.35 a.m. Weston–Paddington on Saturday 11 August 1962. This was the last year that most Bristol–Paddington trains were steam-hauled on Summer Saturdays, with only two surviving into 1963.

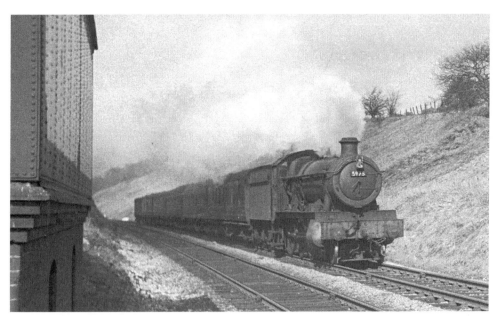

In summer 1962, No. 5975 *Winslow Hall* (82B) passes Fox's Wood, west of Keynsham, with a local passenger train. The water tank on the left serviced the water troughs, used to replenish locomotive tenders at speed, that were formerly located here.

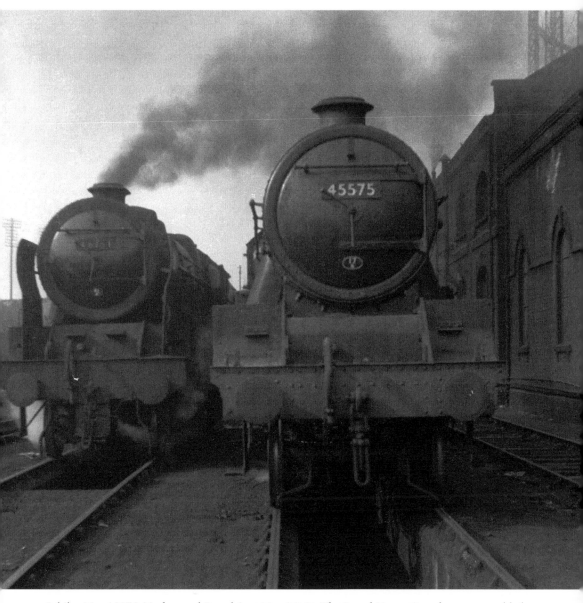

Jubilee No. 45575 *Madras* and Royal Scot No. 46151 *The Royal Horse Guardsman* are stabled at the side of Barrow Road Shed, waiting to take northbound departures on Saturday 30 June 1962. No. 45575 departed on 1N65 6.45 a.m. Paignton–Bradford (brought into Bristol by D819 *Goliath*) and No. 46151 worked 1E68 12.15 p.m. Weston–Sheffield, a regular working for a Sheffield Darnall Jubilee or Scot that summer. (John Freeth)

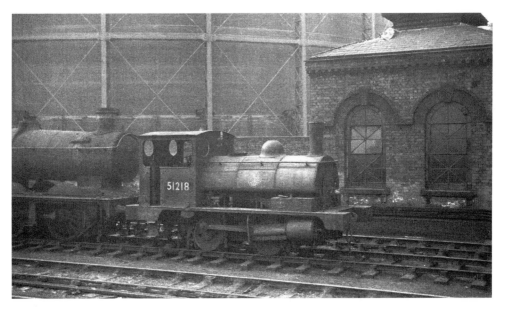

Dwarfed by the gas holder, former Lancashire & Yorkshire Railway Pug No. 51218 (82E) and No. 2229 (82E) are stabled in the engine sidings at Barrow Road shed in September 1962. No. 51218 and sister engine No. 51217 were used by Barrow Road on the Avonside sidings, which had very tight radii. No. 51218 survived, transferred to Swansea and eventual preservation.

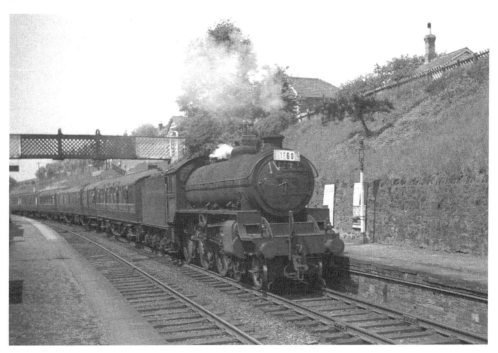

In Summer 1961, B1 No. 61154 heads north through Staple Hill station with 1E60 12.04 p.m. Weston (Locking Road)–Sheffield (SO). The varied coaching stock highlights the intensive use of all stock at the height of the summer.

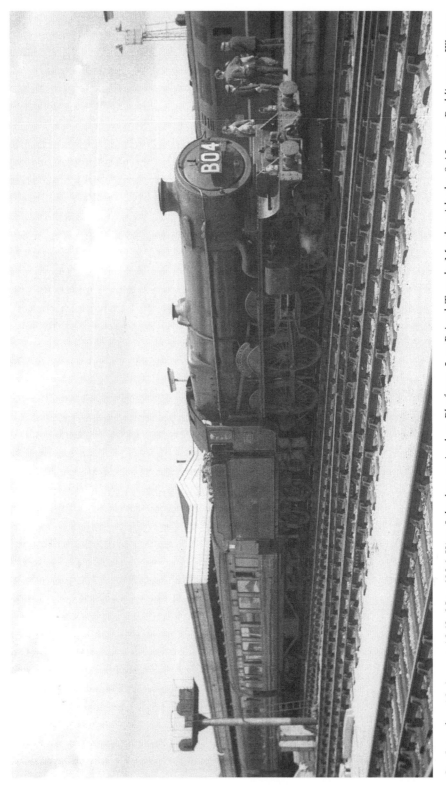

On Saturday 18 August 1962, No. 6026 *King John* has arrived at Platform 5 at Bristol Temple Meads with the 8.45 a.m. Paddington–Weston. Unusually on this date, Old Oak Common have not provided the 'Bristolian' headboard for this train, a common practice during its last summer of steam haulage. Note the LMS stock added to the usual 'Bristolian' set.

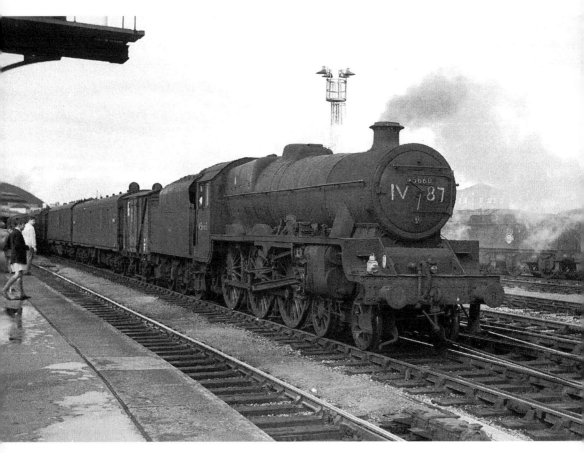

Ex-Bristol Barrow Road Jubilee No. 45660 *Rooke*, the engine used on the Bristol–Glasgow and return tests in October 1937, finds itself on a more mundane, if unusual, turn on Saturday 15 September 1962. It had arrived in Bristol on a North to West train and St Philip's Marsh rostered the Jubilee for 3C04 3.32 p.m. Bristol–Plymouth parcels. Having worked as far as Exeter, the authorities deemed no further, and it was turned on Exeter shed and despatched light engine back to Bristol.

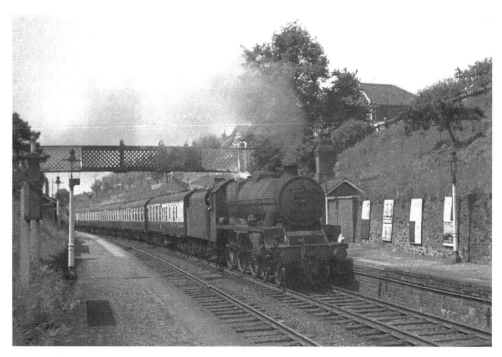

Jubilee No. 45694 *Bellerophon* heads the northbound 'Devonian' 1N37 9.30 a.m. Paignton–Bradford through Staple Hill on Saturday 2 June 1962. The chocolate and cream stock of Western Region-named trains worked through to the North East on the 'Devonian'.

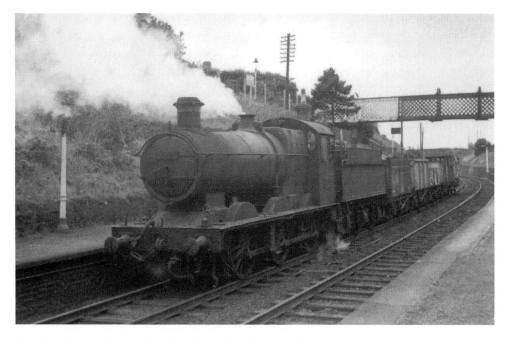

Tuesday 31 July 1962 and Collett No. 2229 (82E) works wrong line on an engineer's train at Staple Hill station. The station closed to passengers on 7 March 1966.

Southern Light Pacific No. 34051 *Winston Churchill* was a surprise visitor to Bristol on Saturday 11 August 1962. Rather than send it home light engine, it piloted No. 4960 *Pyle Hall* (82B) on 1O58 10.50 a.m. Bristol–Portsmouth Harbour, probably as far as Salisbury. In January 1965, it hauled the funeral train of Sir Winston Churchill and was subsequently preserved.

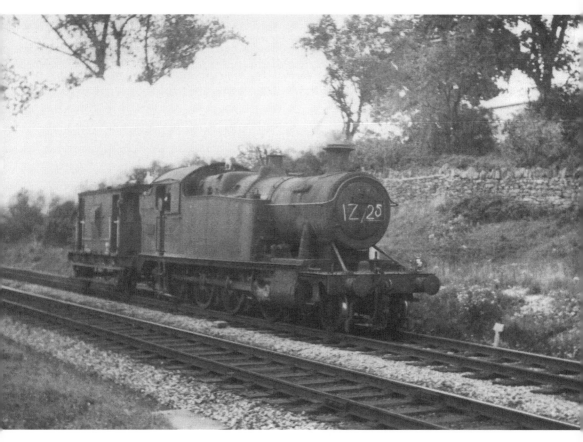

Churchward 2-8-0 Tank No. 5215 (82B) hurries a toad brake van near Keynsham on Saturday 1 September 1962. For a locomotive of this class to carry a reporting number was unusual, but we have been unable to ascertain the circumstances. The actual reporting number 1Z25 indicates a special passenger train was frequently used.

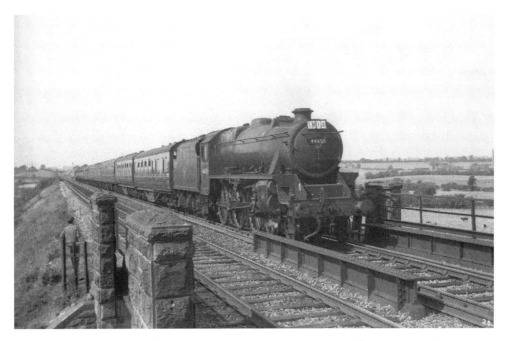

Black Five No. 44658 works 1M18 8.20 a.m. Paignton–Nottingham at Winterbourne on Saturday 1 September 1962. This train was one of the holiday extras, which avoided Temple Meads and changed engines at St Philip's Marsh.

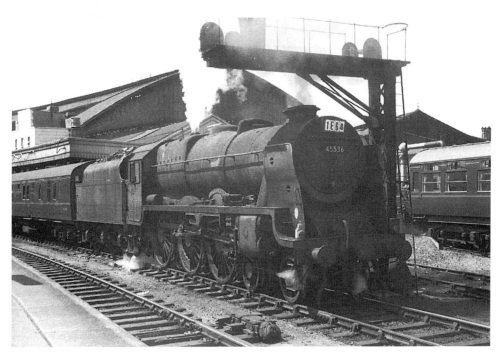

Having worked in from Weston, Rebuilt Patriot No. 45536 *Private W. Wood VC* waits to depart from Platform 6 with 1E68 12.15 p.m. Weston–Sheffield on Saturday 4 August 1962.

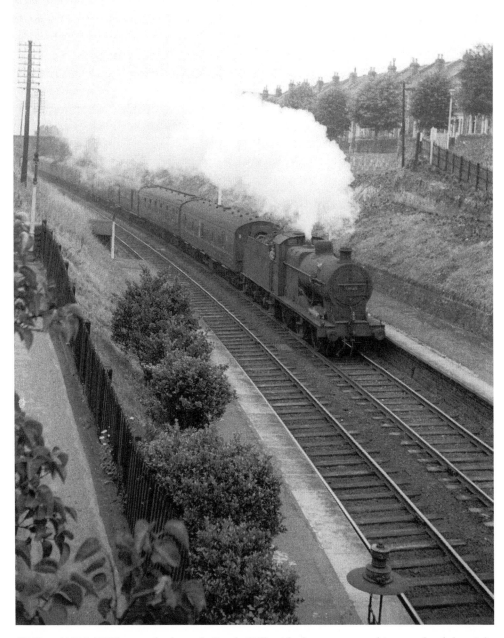

4F No. 44135 (82E) pounds through Staple Hill with the empty coaching stock of the night mail, 1V22 7.05 p.m. Newcastle–Bristol, due in Temple Meads at 5.14 a.m., on 28 July 1962. With the TPO collection apparatus required on the left-hand side, the stock was taken during the morning from Barrow Road carriage sidings to the Mangotsfield triangle for turning, ready to leave Bristol on 1N59 7.25 p.m. to Newcastle.

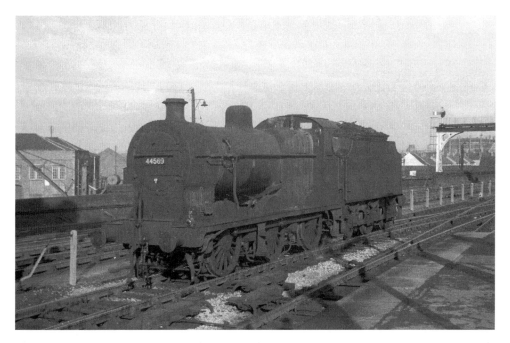

Barrow Road rostered two engines for Midland empty coaching stock manoeuvres at Temple Meads. In the early 1960s, the favourites were Nos 44135 and 44569 (seen here), although other 4Fs and Standard 5s were used.

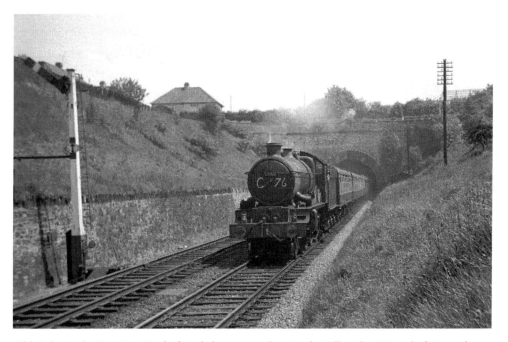

Old Oak Castle No. 5060 *Earl of Berkeley* approaches Staple Hill with 1C76 relief *Cornishman* 9.13 a.m. Wolverhampton–Kingswear on Saturday 2 June, 1962. No. 5060 would be withdrawn two weeks after this photo was taken.

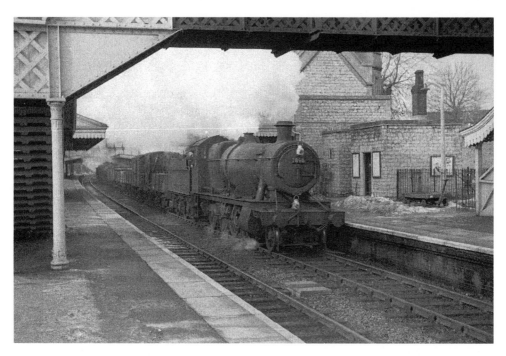

Collett 2-8-0 No. 2898 of Reading shed thunders through Keynsham on a mixed freight.

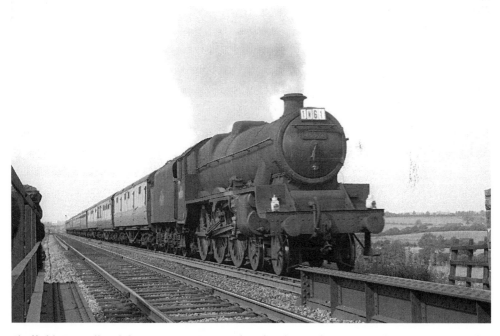

Sheffield Darnall Jubilee No. 45576 *Bombay* heads north at Winterbourne on Saturday 1 September 1962, with 1N61 7.45 a.m. Paignton–Newcastle. This train changed engines at St Philip's Marsh, avoiding Temple Meads station and joining the Midland main line at Yate.

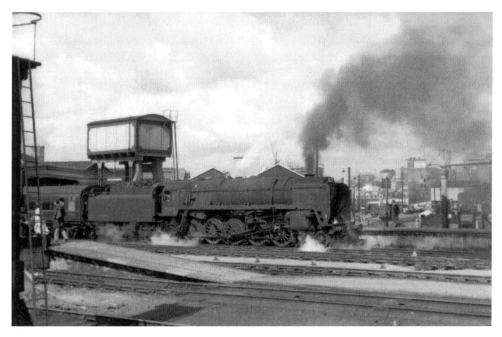

BR 9F 2-10-0 No. 92008 prepares to depart northwards from Platform 9 at Bristol Temple Meads with a Summer Saturday extra in the early 1960s. Although designed as express freight engines, 9Fs would often be pressed into passenger service at the height of the summer (Author's Collection).

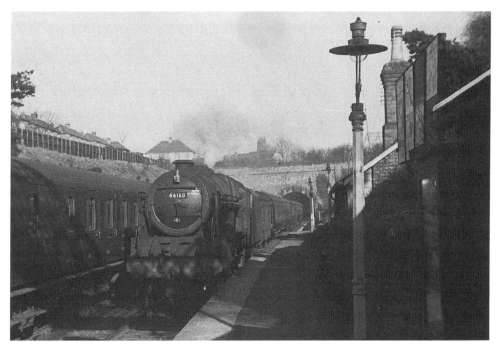

Saltley Royal Scot No. 46160 *Queen Victoria's Rifleman* pulls into Staple Hill with a local train from Gloucester to Temple Meads in March 1962.

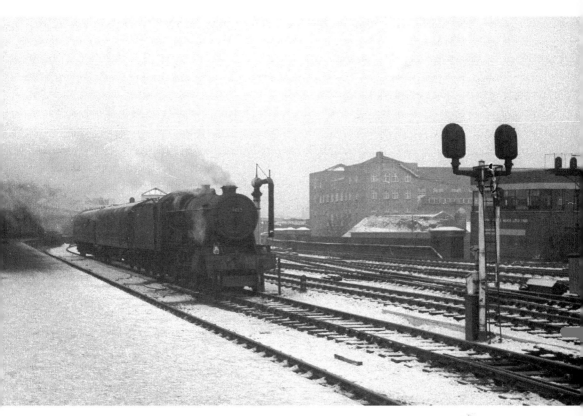

In February 1963, No. 1012 *County of Denbigh*, sporting express headlamps, waits on the middle road at Temple Meads. This was the period of the 'big freeze', which lasted from late December 1962 until early March 1963, during which time steam was in prominence, deputising for failed or unavailable diesels. Further problems were caused by frozen buffet and toilet tanks, resulting in coaching stock shortages.

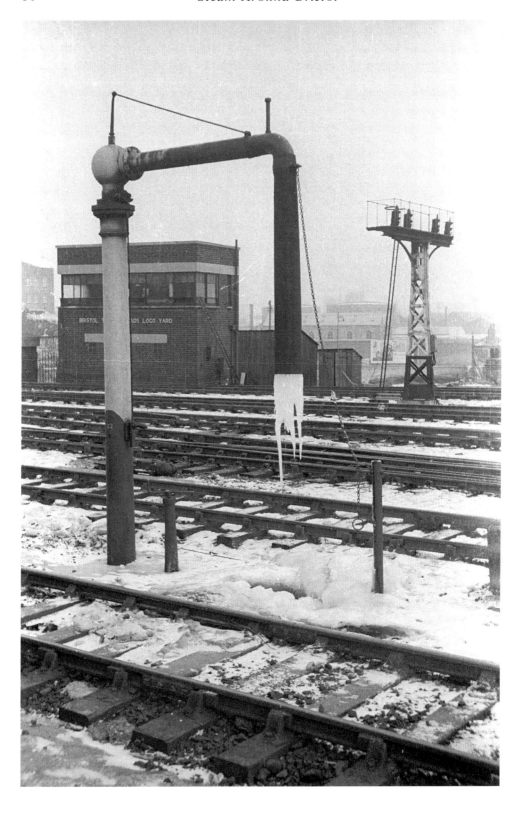

Above: This 1963 view of Bristol St Philip's Marsh (82B), taken from the side of the coaling stage, shows two Counties on shed, the engine in the foreground being No. 1010 *County of Caernarvon*. Of note is the crane adjacent to the pit road, used for clearing ash.

Opposite: The severity of the 1962/3 winter is illustrated by the frozen water column at Temple Meads station.

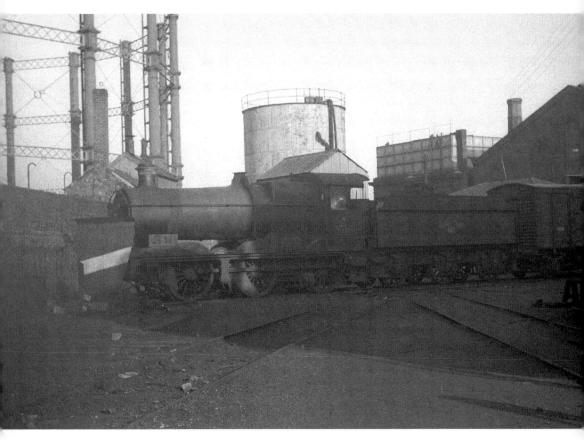

Collett 0-6-0 No. 3218, fitted with a snowplough, stands at the rear of its home-based shed, Barrow Road, in the spring of 1963 at the end of a long, severe winter.

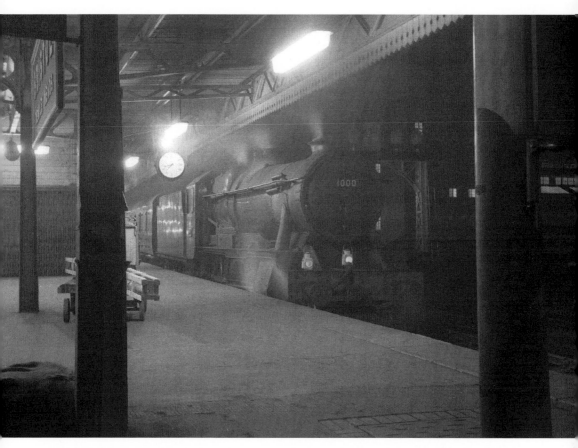

Framed by the pillars supporting the canopy of Platform 1 at Bristol Temple Meads, No. 1000 *County of Middlesex* (82B) has arrived with 2B70 5.20 p.m. Weymouth–Bristol on Friday 6 December 1963. The station clock shows 8.37 p.m. and the empty stock was due to move off to Malago Vale sidings at 8.40 p.m. A Bristol engine for most of its BR life, No. 1000 would be the last County allocated to Bristol, subsequently moving to Swindon in January 1964.

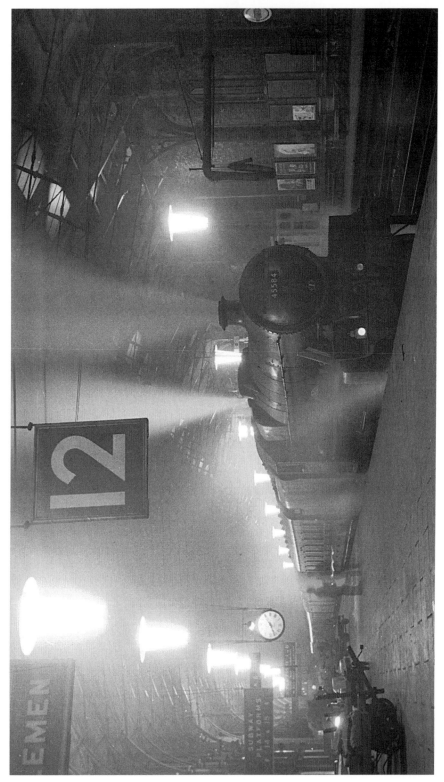

A Blackpool engine for most of its later years, Jubilee No. 45584 *North West Frontier* was allocated to Saltley for eight months in 1963. On Thursday 14 November 1963, she has 6 minutes to wait before departing from Platform 12 at Temple Meads with 3N10 8.15 p.m. Bristol–Leeds parcels. The atmosphere of the old station is clearly illustrated in this photo.

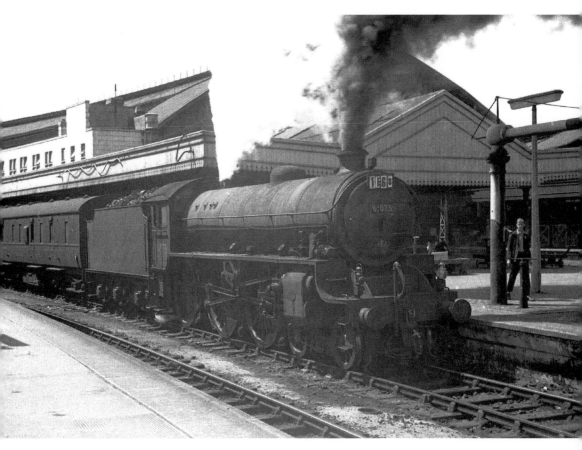

Darkening the sky, Mexborough B1 4-6-0 No. 61075 prepares to depart from Platform 6 at Bristol Temple Meads with 1E68 12.15 p.m. Weston–Sheffield on Saturday 27 July 1963. B1s from the Sheffield area were common visitors to Bristol on Summer Saturdays in 1963/4. This train was worked from Weston to Bristol by the engine from the 1V28 6.40 a.m. Derby–Weston earlier in the day. On this occasion, diesel-electric Peak Class D147 gave way to No. 61075.

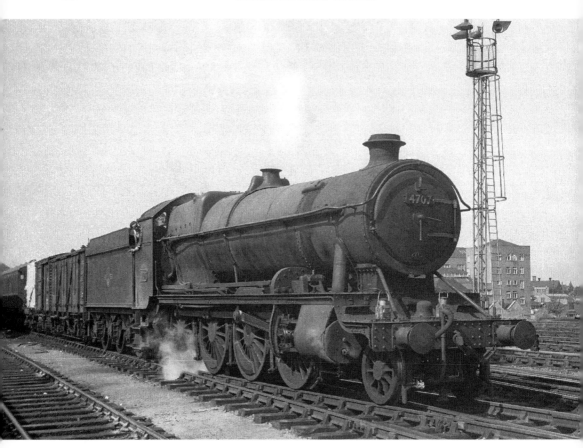

Churchward 'night owl' 2-8-0 No. 4707, based at Southall shed, waits in the middle road at Platform 4, heading 3C04 3.32 p.m. Temple Meads–Plymouth parcels on Saturday 27 July 1963. This small class of nine engines were given their nickname as they worked fast night freights. Didcot is currently recreating an example of the class, using parts from donor Barry engines.

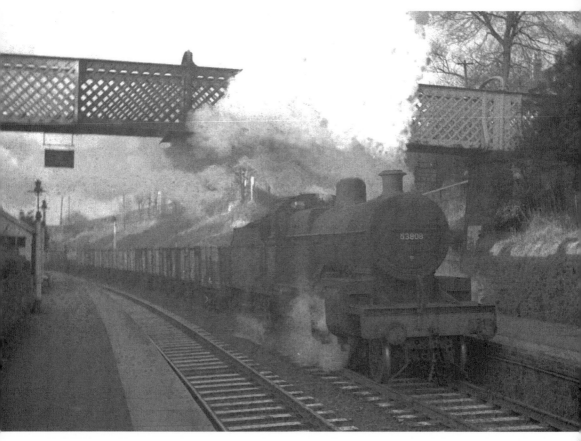

Somerset & Dorset 8F 2-8-0 No. 53808 heads an empty mineral train through Staple Hill station on Saturday 30 November 1963. Bath Green Park shed used these engines on trip freight working to Westerleigh, St Philip's Yard and Stapleton Road Gas Works, using the line through Eastville at Kingswood Junction.

On Saturday 27 July 1963, No. 5975 *Winslow Hall* (82B) heads out of Platform 6 at Temple Meads with 2B40 9.43 a.m. Bristol–Weymouth. It was unusual at this late stage to see engines on local duty with reporting numbers.

Collett large prairie tank No. 8102 (82E) drifts through Lawrence Hill on a mixed freight on Tuesday 10 September 1963. The coach immediately behind the engine is a clerestory vehicle, probably in departmental use. (Patrick O'Brien)

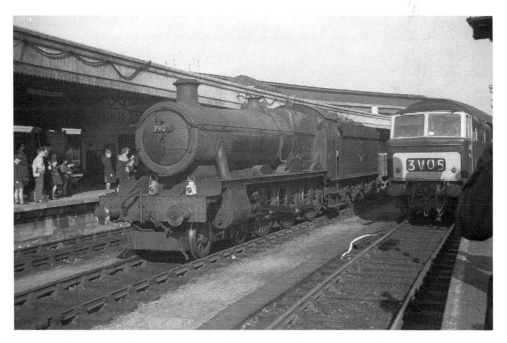

On Saturday 19 October 1963, preserved LNER pacific No. 4472 *Flying Scotsman* visited Bristol. Prior to its arrival, No. 7907 *Hart Hall* (82B) passed through on 8C30 8.05 a.m. Gloucester–Newton Abbot Hackney Yard.

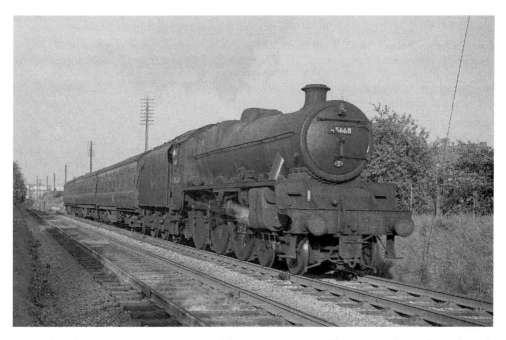

On Wednesday 22 May 1963, Burton Jubilee No. 45668 *Madden* approaches Fishponds with 2B74 5.40 p.m. Gloucester–Bristol local.

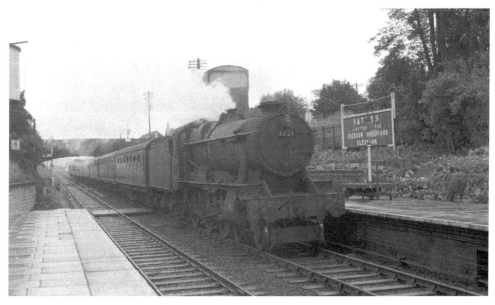

On a Down local passenger service in 1963, No. 1021 *County of Montgomery* (82B) pulls into Yatton station. Then a busy junction, Yatton boasted branches to Cheddar, Wells and Witham, and Clevedon. The Clevedon branch was 14XX operated with a Bath Road loco, outbased at Yatton, but was operated by diesel multiple units from 8 August 1960, surviving longer than the other Bristol area branches and not closing until October 1966. The Cheddar Valley line passenger service remained steam-hauled until it was closed to passengers from September 1963.

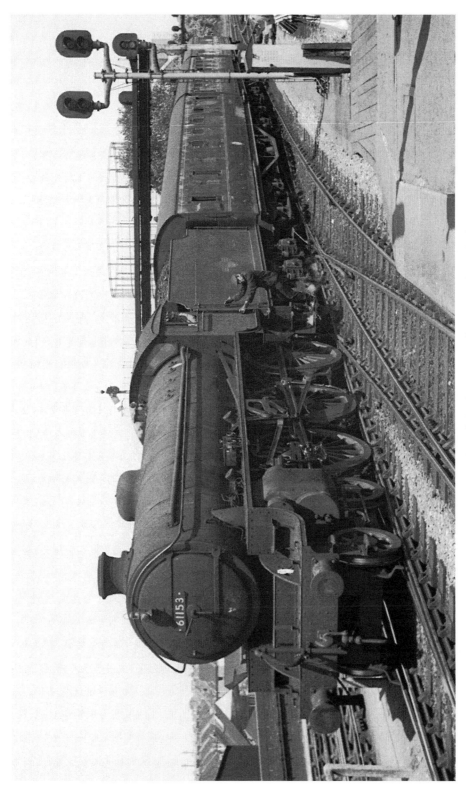

On Saturday 27 July 1963, Canklow B1 No. 61153 pauses to let off the fireman on the approach to Platform 14 at Bristol Temple Meads on 2B74 12.40 p.m. Gloucester–Bristol local.

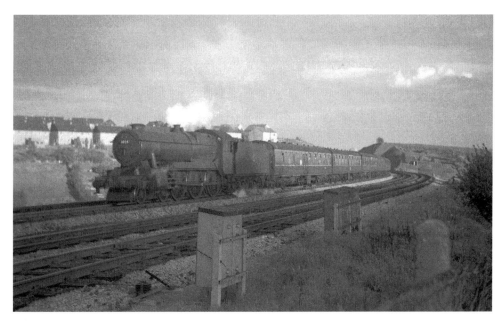

In May 1963, No. 1024 *County of Pembroke* (82B) tackles Ashley Hill bank with 1M96 2.00 p.m. Plymouth–Manchester train. This was one of a number of North to West trains, which reverted to steam haulage during April to June 1963, when Warship availability was poor.

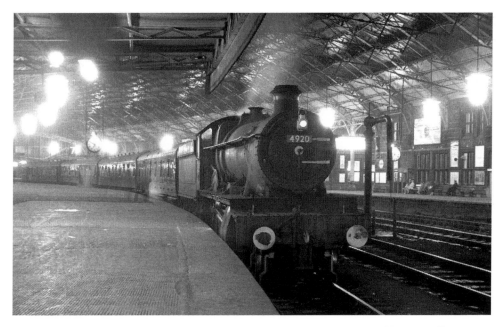

On Friday 29 November 1963, Plymouth Laira Hall No. 4920 *Dumbleton Hall* waits at Platform 7 on 2B90 7.00 p.m. Temple Meads–Weymouth. This train remained steam–hauled until 2 January 1965. No. 4920 was allocated to Bristol Barrow Road in June 1964 and was the last surviving Hall in the 49xx series. Withdrawn in December 1965, No. 4920 would be rescued from Barry and is currently at the South Devon Railway.

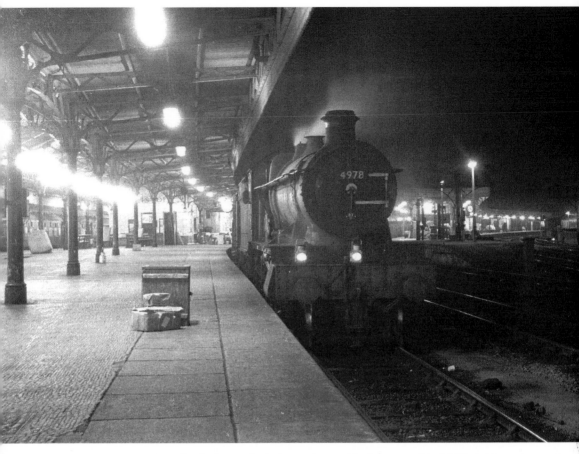

No. 4978 *Westwood Hall* of Plymouth Laira waits at Platform 4 with 3C07 8.10 p.m. Bristol–Plymouth parcels on Friday 27 September 1963. Although Plymouth Laira had been renumbered 84A earlier in the month, No. 4978 retains its 83D shed plate.

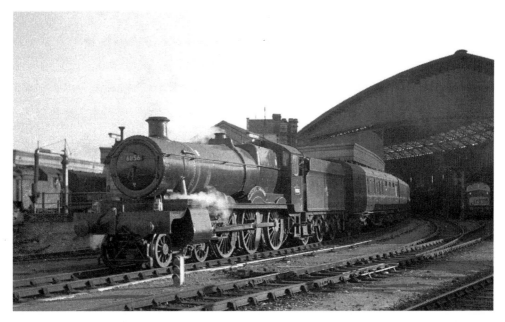

Ex-works No. 6856 *Stowe Grange* departs from Platform 7 at Temple Meads with 2B25 6.40 p.m. Weston–Swindon holiday train on Thursday 25 July 1963. The Warship diesel in the centre road had brought in 1M99 12.00 p.m. Penzance–Manchester and will go forward on 1A50 7.00 p.m. Weston–Paddington.

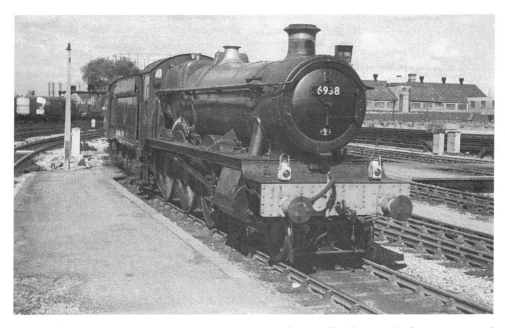

On Saturday 13 July 1963, ex-works No. 6938 *Corndean Hall* pulls into Platform 4 at Bristol Temple Meads with the late-running 1B15 12.45 p.m. Paddington–Weston. The train, normally hauled by a Hymek Type 3 diesel-hydraulic, had suffered an engine failure, probably at Reading, and No. 6938 would have been one of the Reading pilots.

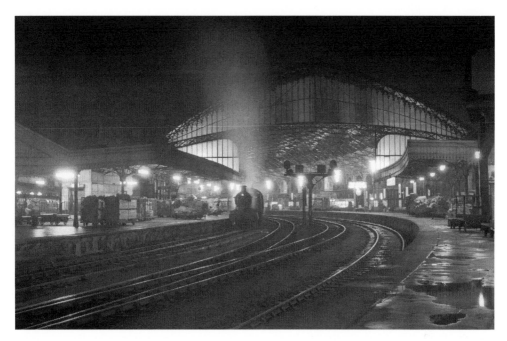

After heavy rainfall on Wednesday 13 November 1963, No. 6955 *Lydcott Hall* waits for the off with 2B90 7.00 p.m. Bristol–Weymouth. The amount of parcels traffic handled by the railways in the 1960's is clear from at least fifteen fully loaded trolleys and cages visible in the photo.

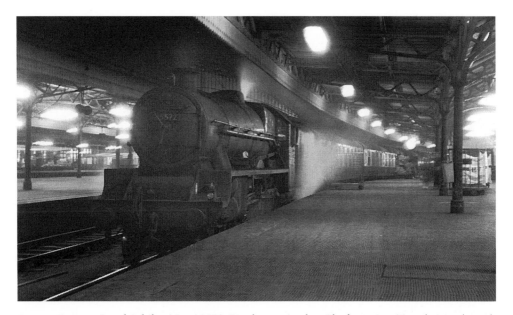

Former Barrow Road Jubilee No. 45572 *Eire* has arrived at Platform 5 at Temple Meads with 1V98 3.05 p.m. Manchester–Plymouth (with through carriages from Glasgow) on Thursday 14 November 1963. This may well have been its last visit to Bristol, as the engine was withdrawn six weeks later. Originally named *Irish Free State*, No. 45572 was renamed *Eire* in September 1938, one of a few Jubilees to be renamed.

Pannier Tank No. 9642 hauls Hymek D7033 on to Bath Road diesel depot. Withdrawn at the end of 1964, it was sold for scrap to Hayes of Bridgend, but was used by them to shunt the yard for three years, before eventually being saved for preservation.

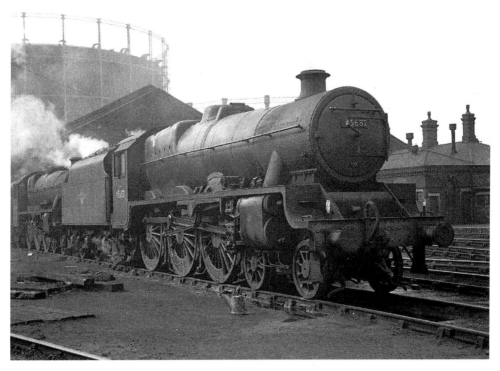

Jubilee No. 45682 *Trafalgar* (82E) and an unidentified member of the class are stabled in the short siding at the front of Barrow Road shed in 1963. No. 45682 would be the shed's last surviving Jubilee when it was withdrawn on Wednesday 3 June 1964.

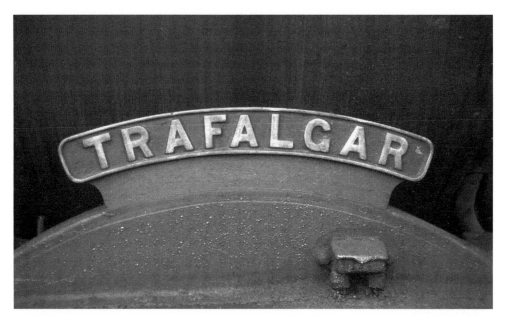

Nameplate of Jubilee No. 45682 *Trafalgar* (82E), pictured on Saturday 7 December 1963 before working 2H74 12.46 p.m. Bristol–Gloucester local.

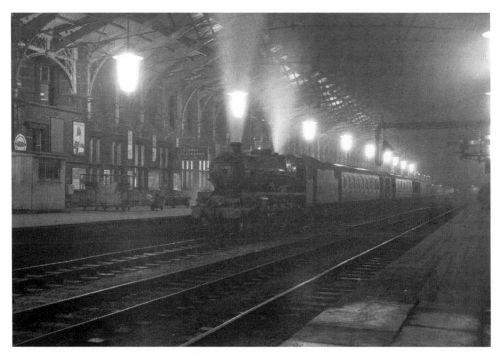

Preparing for departure on Monday 27 January 1964, Jubilee No. 45682 *Trafalgar* (82E) blows off impatiently on 3N10 8.15 p.m. Bristol–Leeds parcels. Many features of the old station in Bristol remain and there are plans to re-use former Platform 12 for trains on the newly electrified route to Paddington.

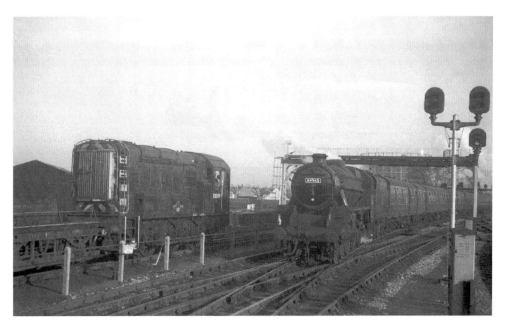

On a sunny Monday 30 December 1963, Saltley Black Five No. 44965 had worked into Bristol on 1V31 7.35 a.m. Nottingham–Bristol, and is now being towed back to Barrow Road by the empty coaching stock pilot. No. 44965 survived almost to the end of steam, being withdrawn from Bolton in April 1968.

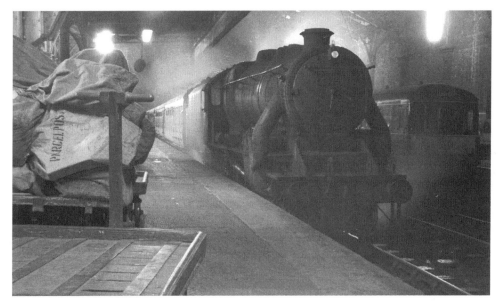

Leeds Holbeck Black Five 4-6-0 No. 44753 waits to depart from Platform 12 at Bristol Temple Meads with 2M74 6.30 p.m. Bristol–Birmingham stopping service on Monday 4 November 1963. No. 44753 was one of a small batch of experimental Black Fives introduced in 1948 with Caprotti valve gear and Timken roller bearings. Their appearance was not enhanced and local railwaymen referred to them as 'gorillas'.

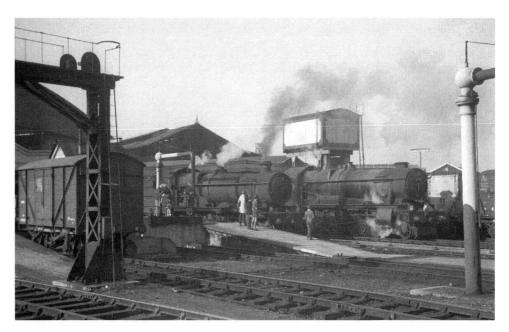

County No. 1000 *County of Middlesex* heads out from the middle road at Bristol Temple Meads with 4B42 4.30 a.m. Tavistock Junction–Avonmouth freight passing No. 4972 Saint Brides Hall at Platform 7 on 2T02 10.35 a.m. Bristol–Cardiff passenger on Saturday 12 October 1963. Both trains were scheduled for diesel haulage at this stage by a Warship and DMU respectively.

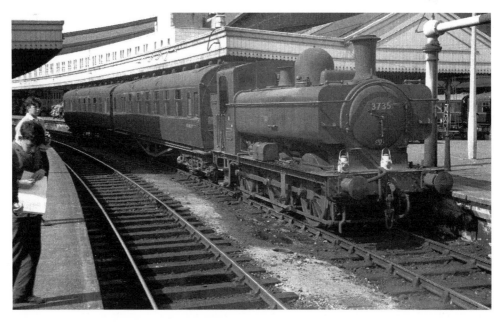

Pannier tank No. 3735 has arrived at Platform 6 at Bristol Temple Meads with the 8.22 a.m. from Witham on Saturday 27 July 1963. The last trains would run on the East Somerset and Cheddar Valley lines just seven weeks later.

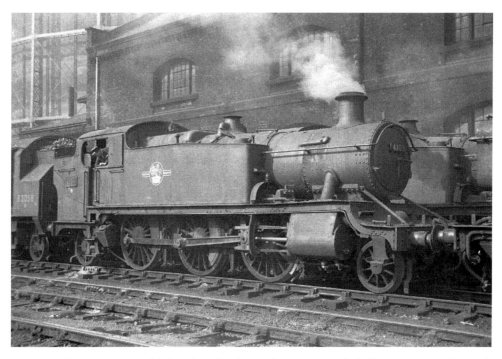

Prairie Tank No. 4103 is stabled at the side of Bristol Barrow Road Shed in 1963. Together with classmate No. 4131, it worked over the North Somerset line until dieselisation in June 1964. Although never officially reallocated, the pair were, in fact, transferred to Taunton Shed, from where they were withdrawn in the autumn of 1964.

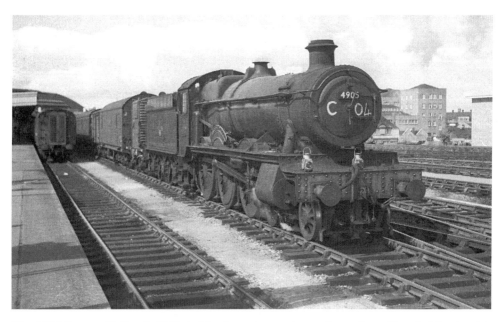

No. 4905 *Barton Hall*, a St Philip's Marsh engine, waits to depart from Temple Meads with 3C04 3.32 p.m. Bristol–Plymouth parcels on Saturday 13 July 1963.

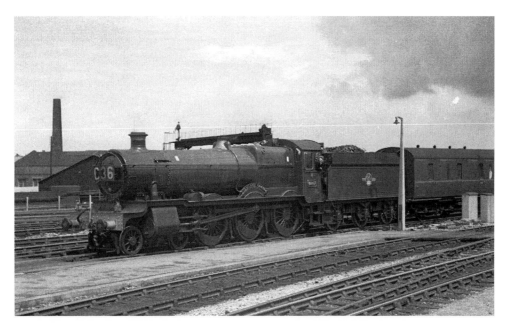

No. 6847 *Tidmarsh Grange* arrives at Platform 5 at Bristol Temple Meads with 1C36 7.55 a.m. Carmarthen–Penzance on Saturday 13 July 1963. The train would be taken forward from Bristol by Warship D803 Albion, arriving in Penzance at 7.30 p.m. after a journey of nearly twelve hours!

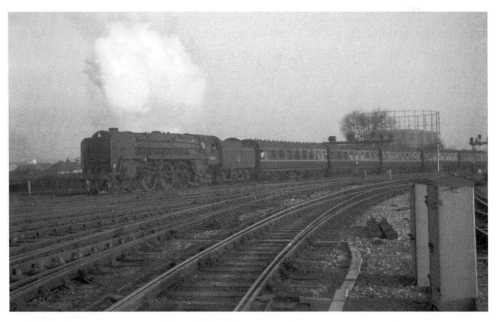

Willesden Britannia pacific No. 70012 *John of Gaunt* heads 2B74 9.30 a.m. Gloucester–Bristol local into Platform 12 at Temple Meads on Saturday 28 December 1963. This train was rostered for a Peak diesel but, from mid-December, reverted to steam haulage for two weeks, probably to release the diesel for Christmas parcels and passenger extras.

Britannia No. 70017 *Arrow* waits impatiently in Bristol Temple Meads goods yard on 4M52 7.50 p.m. to Manchester on Friday 8 November 1963. The steep incline can be seen in the photo and engines would struggle to lift the train on to level track. The train was dieselised from 15 June 1964, but was occasionally steam-worked after that date.

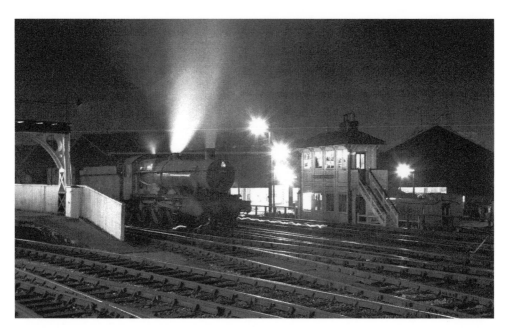

Swindon-allocated No. 4991 *Cobham Hall* waits at Temple Meads goods yard with 5H43 9.10 p.m. to Oxley on Friday 18 October 1963. This turn remained steam-hauled until the official end of steam in Bristol in November 1965. The line originally extended past St Mary Redcliffe church, through a short tunnel to Wapping Wharf and the docks area.

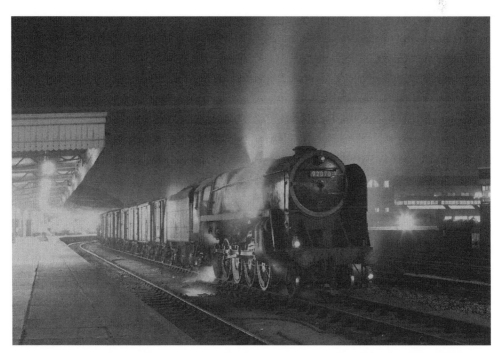

On Thursday 14 November 1963, 9F No. 92070 pauses at Temple Meads with a freight for West depot.

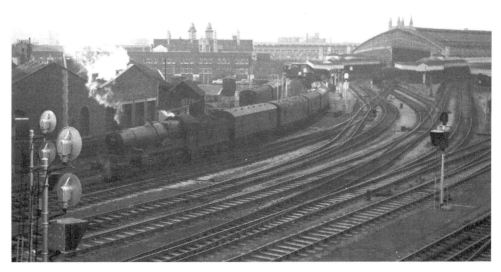

Taken from Bath Road Bridge, Castle No. 5056 *Earl of Powis* of Oxley shed has arrived in Bristol with 3B37 1.30 p.m. Pontypool Road–Bristol parcels in November 1963 and is shunting the stock in Platform 11. On the left of the photograph, Collett House (now demolished) can be seen and, in the centre, the Bristol and Exeter building. (Patrick O'Brien)

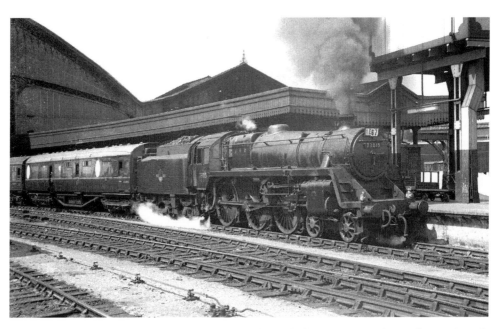

Standard Class 5 4-6-0 No. 73015 (82E) departs from Platform 9 at Bristol Temple Meads with 1N48 9.00 a.m. Paignton–Leeds on Saturday 27 July 1963. Note the LNER Thompson coach at the front of the train. A Barrow Road engine for most of its short life, No. 73015 has been given reporting number 1E67 in error.

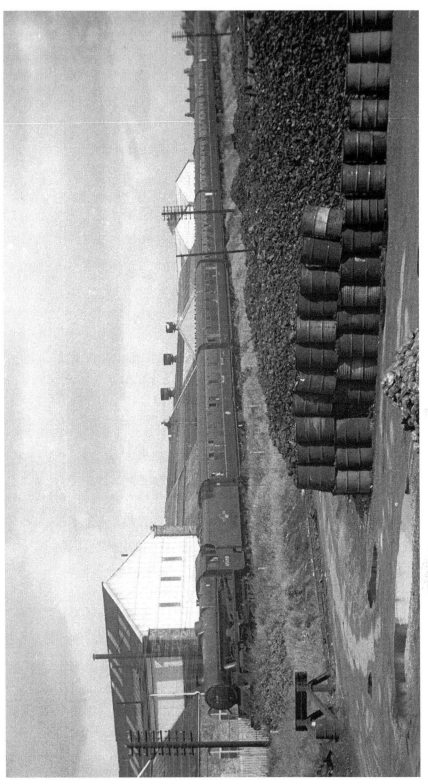

Drifting down Fishponds Bank at the approach to Barrow Road, Jubilee No. 45690 *Leander* (82E) heads 1V31 7.35 a.m. Nottingham–Bristol on Monday 9 September 1963. Peaks were in short supply on that date and No. 45690 was rostered to return north on 1N87 5.40 p.m. Bristol–York. The coal yard, used by local merchants, is part of Lawrence Hill goods depot. Withdrawn the following March, No. 45690 was rescued from Barry and, at the time of writing, works steam specials in the North of England. (Patrick O'Brien)

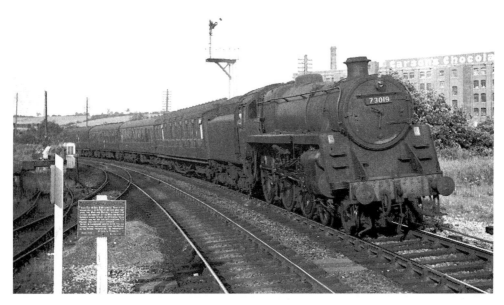

On Tuesday 16 July 1963, Standard Class 5 No. 73019 pulls into Mangotsfield station with 2B74 5.40 p.m. Gloucester–Bristol local. These local services ceased from January 1965 but Mangotsfield station remained open until 7 March 1966, being served by the Bath Green Park–Bristol service. At that time Bath Green Park and all the intermediate stations to Bristol Temple Meads closed.

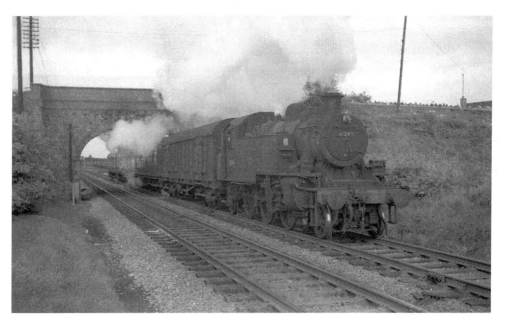

Wednesday 1 May 1963 sees Ivatt tank No. 41249 (82E) head a local from Bristol to Bath Green Park. The train has passed under Forest Road bridge and the coal yard at Fishponds station is visible in the distance.

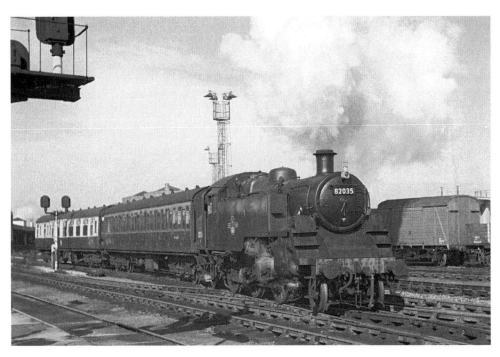

Standard Class 3 Tank No. 82035 (82E) sets off from Bristol Temple Meads in April 1963 with a short train for Portishead, consisting of an unusual pairing of coaching stock.

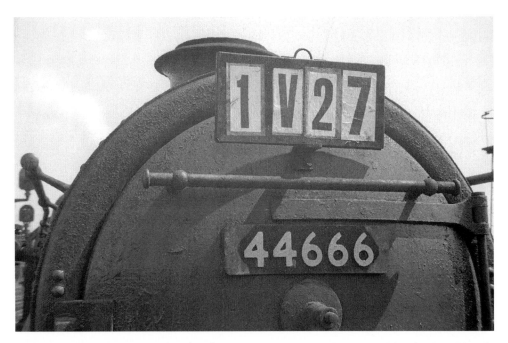

1V27 was the reporting number for the 6.40 a.m. Leicester–Paignton (SO), due into Temple Meads at 11.03 a.m. The train was steam-hauled from Leicester to Bristol up to 1964. Saltley Black Five No. 44666 worked the train on Saturday 27 July 1963.

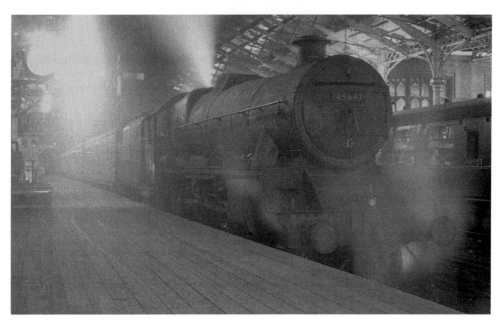

On Friday 18 October 1963, Saltley Jubilee No. 45647 *Sturdee* stands at Platform 15 with 2B74 5.40 p.m. Gloucester–Bristol. Of interest is the wooden platform still in use in this part of the old station at Temple Meads and the semaphore signals controlled by Bristol Old Station signal box, closed in 1965. The engine would survive until April 1967 at Leeds Holbeck.

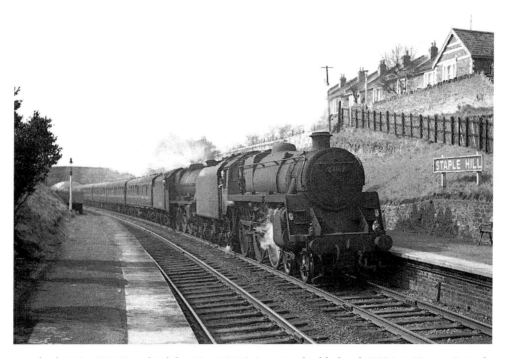

Standard 5 No. 73167 and Jubilee No. 45612 *Jamaica* double-head 1N84 1.40 p.m. Bristol–York through Staple Hill station on Saturday 6 April 1963.

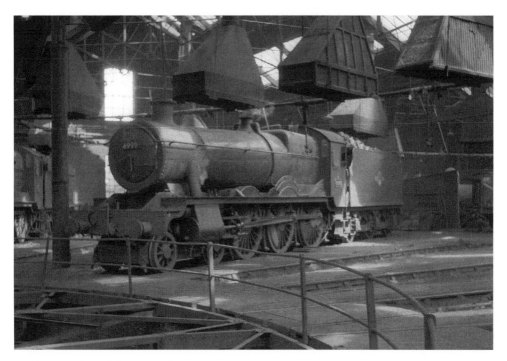

Inside one of St Philip's Marsh's two roundhouses, No. 6999 *Capel Dewi Hall* is at rest on Sunday 3 May 1964. The engine achieved fame by taking over from failed No. 4079 *Pendennis Castle* at Westbury on the 'Ian Allan Special' on 9 May 1964, performing well to Taunton, where it was replaced by No. 7025 *Sudeley Castle*.

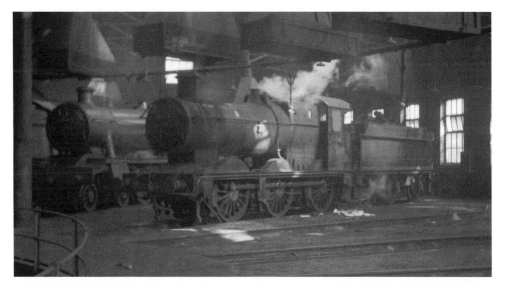

Sunlight and shadows adorn Collett No. 2217 inside one of the roundhouses at Bristol St Philip's Marsh on Sunday 8 March 1964. Allocated to Bristol Barrow Road between December 1962 and December 1963, No. 2217 had been reallocated to Templecombe, but had found its way to St Philip's Marsh in the early months of 1964.

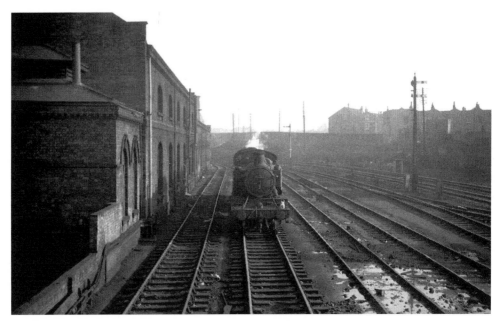

Prairie No. 6130, allocated to Swindon, was a surprise visitor to Bristol Barrow Road for five days in May, 1964. Here seen stabled in the shed sidings, it was used on trip working between Westerleigh Yard and West Depot, a turn generally handled by Midland 4F or 9Fs. By Wednesday May 13 it had gone and was withdrawn some two months later. Within six weeks these sidings would be full of engines on the closure of St Philip's Marsh Shed.

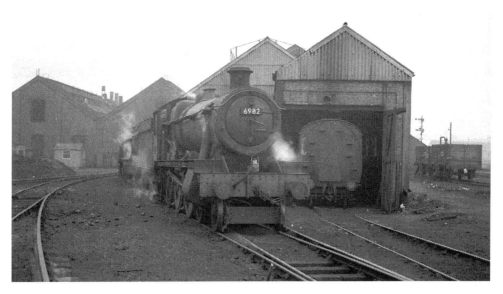

In May 1964, No. 6982 *Melmerby Hall* stands outside one of the roundhouses at Bristol St Philip's Marsh Shed in the month before closure. The building on the right was an extension to the repair shed. A Bristol engine for much of its life, No. 6982 is still sporting an 82A Bristol Bath Road shedplate, some four years after the closure of that shed. It was transferred to Bristol Barrow Road and withdrawn in August 1964.

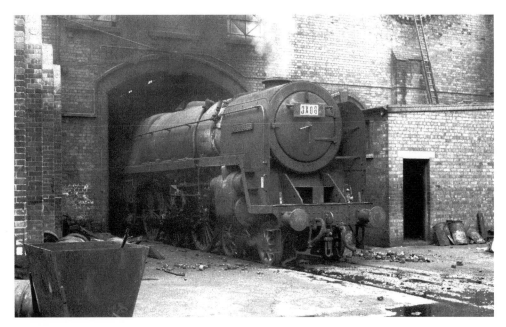

Britannia No. 70042 *Lord Roberts* is stabled at the rear of Barrow Road Shed on Saturday May 23, 1964. The headcode suggests it had worked a special parcels or ECS train earlier in the day and it would return north on the 8.05 p.m. Avonmouth–Carlisle freight. It was customary to turn *Britannias* on the Mangotsfield or North Somerset Junction triangles, but they could be turned with care on Barrow Road's 60ft turntable.

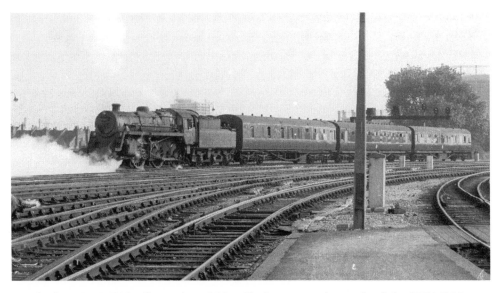

Standard 4 No. 76042, allocated to Saltley Shed, reverses the stock of the 2B74 7.30 a.m. Gloucester–Bristol local to the sidings at Barrow Road Shed on Tuesday September 8, 1964. It would work back to Gloucester on 2H74 3.45 p.m. local, completing similar turns for the next two days. This standard type was relatively uncommon in Bristol, none being allocated to the Western Region. (Patrick O'Brien)

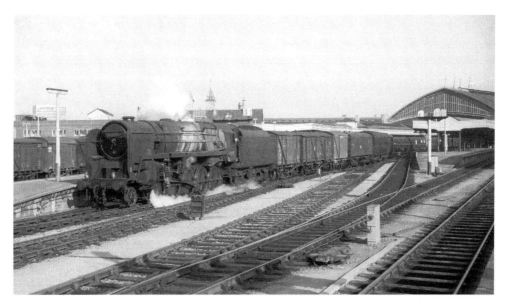

Standard 9F No. 92125 pulls into Bristol Temple Meads with the Bristol stock from the Leicester–Bath Green Park parcels, having earlier worked 4V37 2.45 a.m. Washwood Heath–Westerleigh freight on Saturday 12 September 1964.

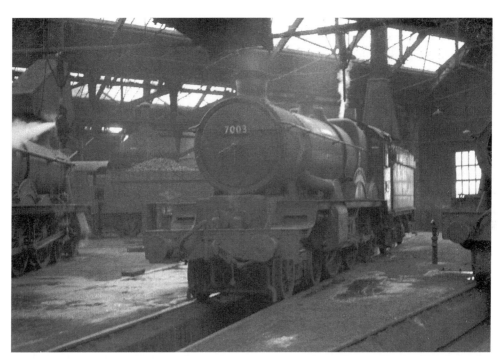

In early 1964, No. 7003 *Elmley Castle* (82B), one of the last two Castles to be allocated to a Bristol shed, is stabled inside St Philip's Marsh. The photo clearly shows the arrangement of the twin turntables inside the shed. No. 7003 would be transferred away to Gloucester (Horton Road) in June and withdrawn in August 1964.

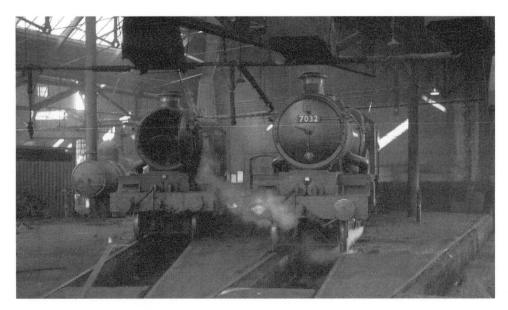

The two Castles prepared for the 'Ian Allan Special', No. 5054 *Earl of Ducie* and No. 7032 *Denbigh Castle*, are stabled inside St Philip's Marsh prior to the railtour on Saturday 9 May 1964. In the event, No. 5054 was used for the final leg from Bristol to Paddington and achieved a top speed of 96 mph.

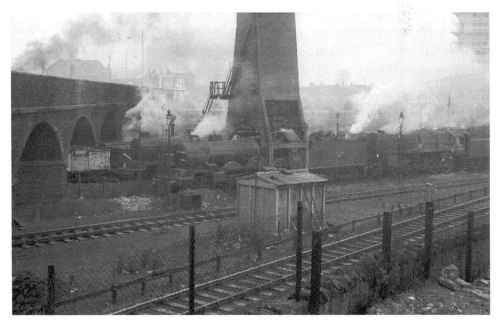

Castles Nos 5054 *Earl of Ducie* and 5056 *Earl of Powis* are serviced under the ash plant at Bristol Barrow Road in the company of No. 92235 on Tuesday 8 September 1964. No. 5054 hauled the last leg of the 'Ian Allan Special' on Saturday 9 May 1964 from Temple Meads to Paddington. This special commemorated the sixtieth anniversary of the celebrated '100 mph' achieved by the 4-4-0 *City of Truro* in May 1904. (Patrick O'Brien)

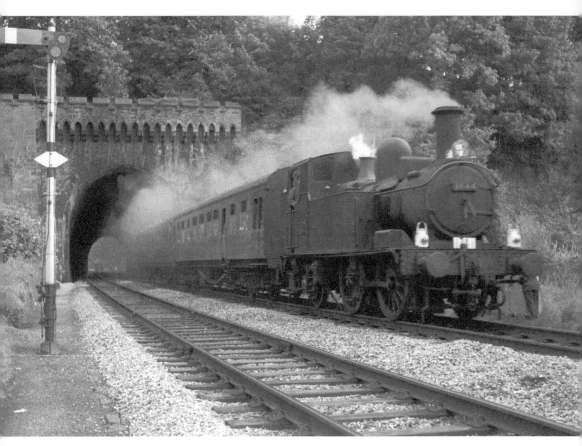

Collett 0-4-2 auto tank No. 1444, carrying express passenger headlamps, emerges from St Anne's Wood tunnel on Sunday 20 September 1964 with special train 1Z41. It worked from Swindon to Calne, thence via Westbury and Bath to Bristol Temple Meads, returning to Swindon via Badminton.

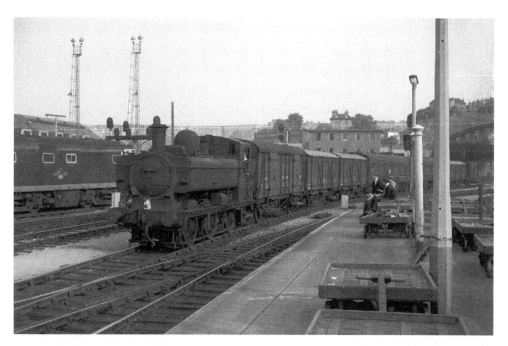

Pannier Tank No. 3643 (82E) heads into Temple Meads on Friday 26 June 1964 with a strawberry special, displaying headlamps for a train conveying perishable goods. Earlier in the day it had headed the 11.25 a.m. to Draycott, a train that was run as required in the summer for the strawberry season.

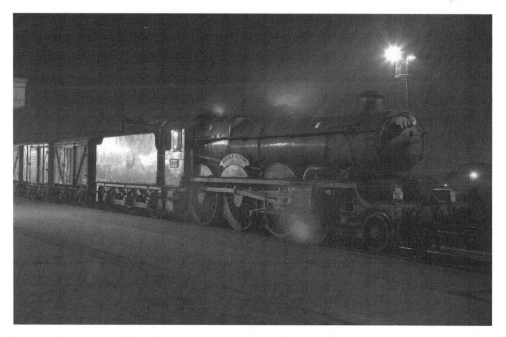

Pausing for water at Temple Meads, No. 5002 *Ludlow Castle* (82B) works 4C25 7.50 p.m. Avonmouth–Tavistock Junction freight on Friday 6 March 1964.

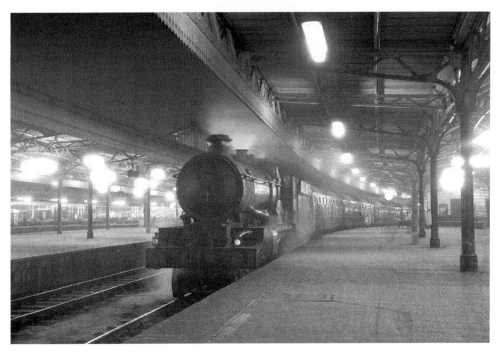

On Friday 3 January 1964, No. 5085 *Evesham Abbey* (82B) waits to take out 1V95 12.05 p.m. Manchester–Plymouth from Platform 5 at Bristol Temple Meads, running 2 hours late. No. 5085 had taken over from No. 5002 *Ludlow Castle* (82B).

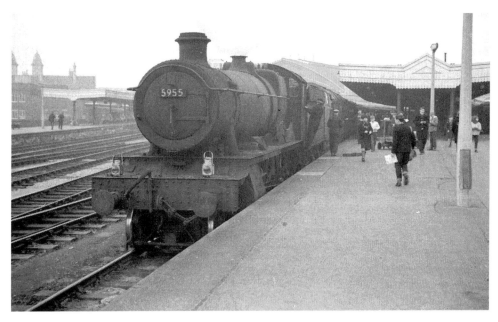

Warship D858 *Valorous* has failed on 1V93 9.05 a.m. Liverpool–Kingswear and Plymouth on Saturday 19 February 1964. No. 5955 *Garth Hall* rescued the train and pulled it into Bristol Temple Meads, where both engines were replaced by another Warship.

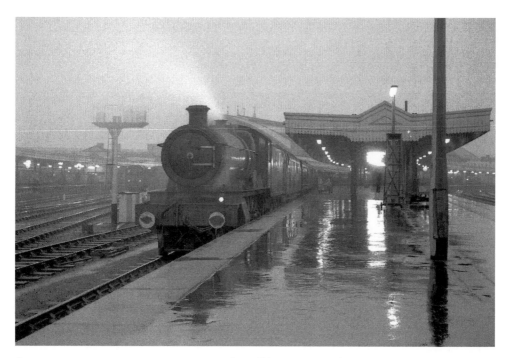

On a very wet evening, No. 6921 *Borwick Hall* has come to the aid of failed Warship D865 *Zealous*, hauling 1B19 2.45 p.m. Paddington–Weston on Thursday 12 March 1964.

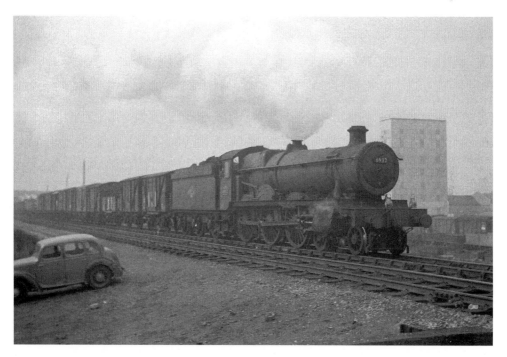

On Saturday 29 February 1964, No. 6932 *Burwarton Hall* passes St Philip's Marsh shed on the Temple Meads avoiding line with an express freight.

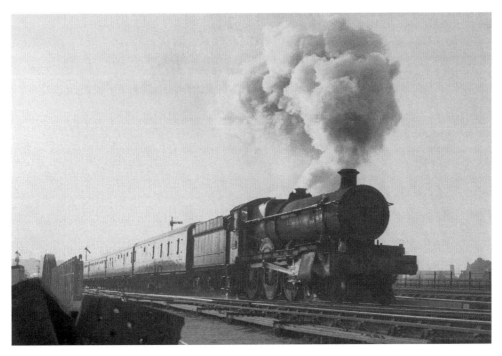

At the head of 2B90 7.00 p.m. Bristol–Weymouth, No. 6821 *Leaton Grange* (82B) storms over the Feeder bridge at North Somerset Junction on Tuesday 5 May 1964. The train would remain steam-hauled until the beginning of January 1965.

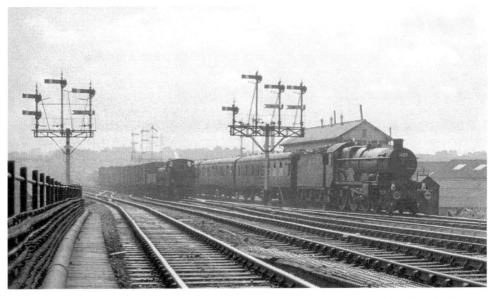

No. 7022 *Hereford Castle* heads past North Somerset Junction towards Temple Meads with 2B46 8.45 a.m. Swindon–Weston holiday train on Thursday 27 August 1964, the penultimate day of steam haulage on this train. The pannier tank will wait for the road with a transfer freight from East depot. (Patrick O'Brien)

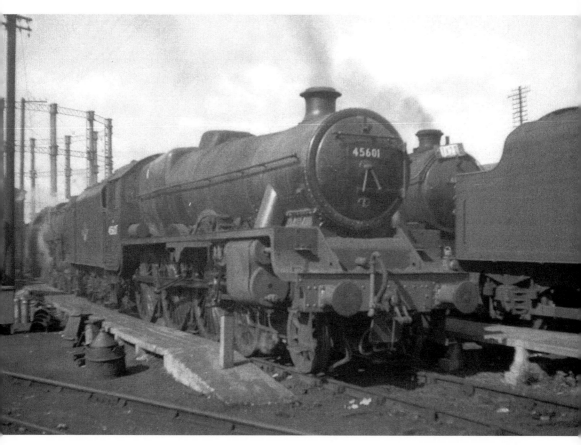

Newton Heath Jubilee No. 45601 *British Guiana* is stabled in the sidings at Barrow Road prior to taking out 1N84 2.15 p.m. Bristol–York on Saturday 20 June 1964. This train, which had been dieselised in summer 1961, reverted to steam haulage on Summer Saturdays in 1963 and 1964. (John Freeth)

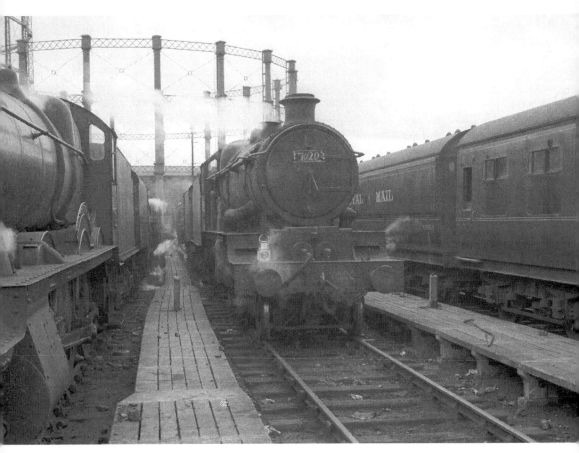

No. 7020 *Gloucester Castle* is in the engine sidings at Barrow Road shed on Saturday 15 August 1964. These sidings were formerly for carriage stock, but were made available for engine stabling on the closure of St Philip's Marsh in June 1964, when Barrow Road became responsible for all steam workings in the Bristol area. The TPO stock will later form 1N59 7.25 p.m. Bristol–Newcastle. The LMS Royal Mail vehicle M30292M was built at Wolverton in 1947 from Diagram 2175, which did not include pick up apparatus. No. 7020, withdrawn a month later, would depart on 1M39 12.10 a.m. Penzance–Wolverhampton.

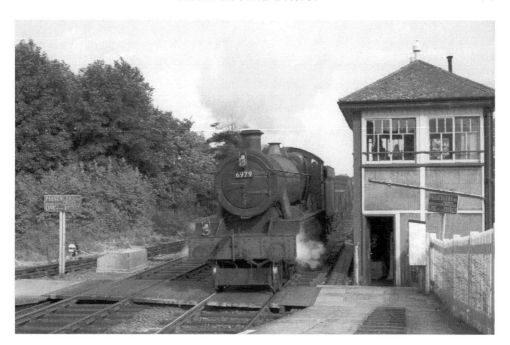

No. 6979 *Helperly Hall* passes Keynsham & Somerdale West signal box with 4V23 2.45 a.m. Tees Yard–Bristol East depot in 1964. The siding into Fry's factory is visible on the left. This closed in September 1978.

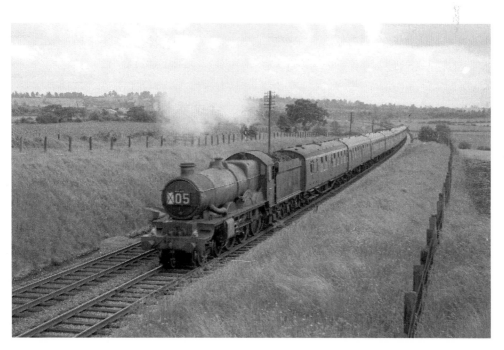

On Sunday 7 June 1964, No. 7023 *Penrice Castle* approaches Yate with 1X05 Home Counties Railway Society 'Somerset and Dorset' railtour. No. 7023, unusually, worked from Bath Green Park to Gloucester, where No. 7025 *Sudeley Castle* took over for the return to Paddington.

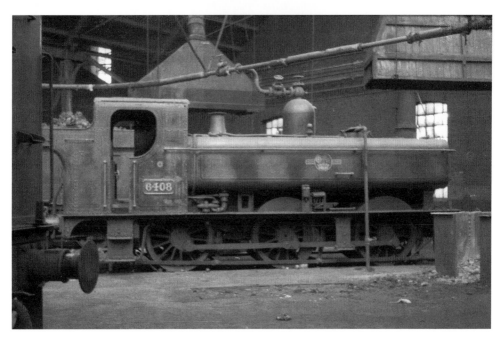

Pannier Tank No. 6408, after withdrawal from Tondu shed (88H) in February 1962, was used as a stationary boiler at St Philip's Marsh from 1962 to 1964. Complete with number plates, it was kept in good external condition, as shown here on Sunday 3 May 1964.

On Thursday 7 May 1964, Pannier Tank No. 7436 (82B) shunts coal wagons into the coaling stage at Bristol St Philip's Marsh. The shed closed to steam in mid-June and No. 7436 was withdrawn.

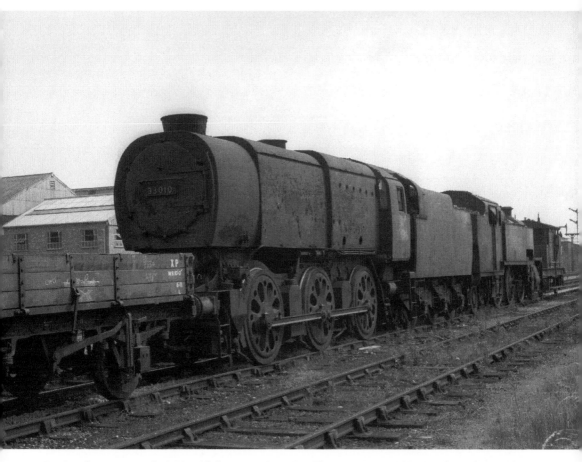

During the summer of 1964, withdrawn engines Q1 Class 0-6-0 No. 33010 and W Class 2-6-4 tank No. 31913 were stored at Yate in transit to South Wales for scrapping. It was not uncommon at this time to see withdrawn Southern locos stored in the Bristol area when en route to South Wales scrapyards.

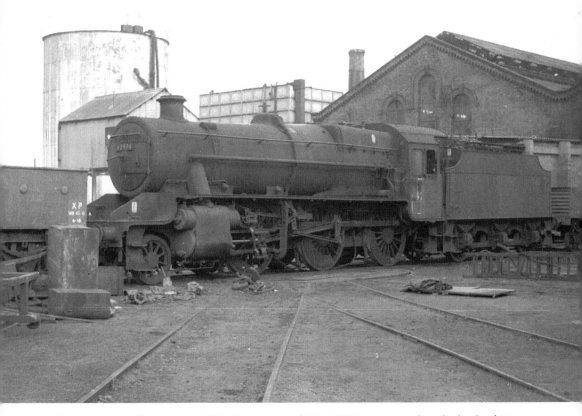

For a number of months in 1964, Stanier mogul No. 42974 was stored at the back of Barrow Road pending repair. It later returned and was used on an empty stock working in Bristol on 5 January 1965, before being transferred away to Gorton (9G). Note the small turntables used for wagons accessing the repair shop.

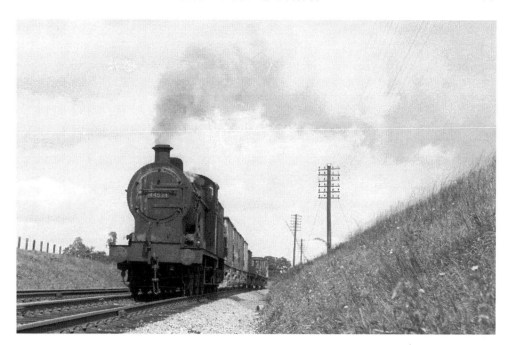

4F No. 44534 (82E) had earlier in the day been rostered for T810 8.55 a.m. Thornbury goods trip and is seen here travelling south with a short freight towards Westerleigh marshalling yard at Yate on Saturday 29 August 1964.

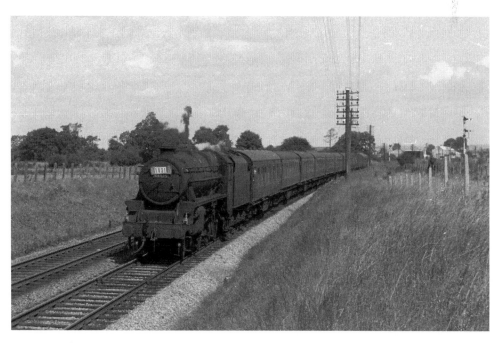

Burton Black Five No. 44825 hurries south of Yate with 1V31 7.43 a.m. Nottingham–Plymouth on Saturday 29 August 1964. The signal on the right controls the southbound connecting chord to the Great Western Paddington–South Wales direct line.

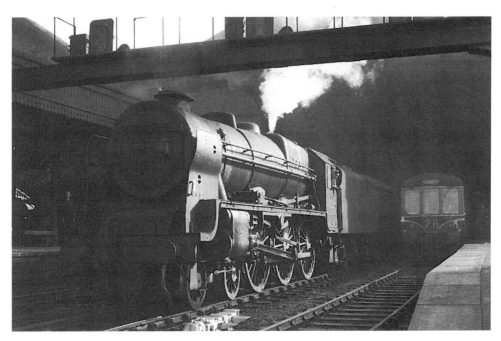

One of the last visits of a Patriot to Bristol, No. 45530 *Sir Frank Ree* has collected stock before backing onto the 2M74 6.30 p.m. stopping train to Birmingham on Wednesday 13 May 1964. The multiple unit on the right formed 2B54 6.15 p.m. Bristol–Severn Beach.

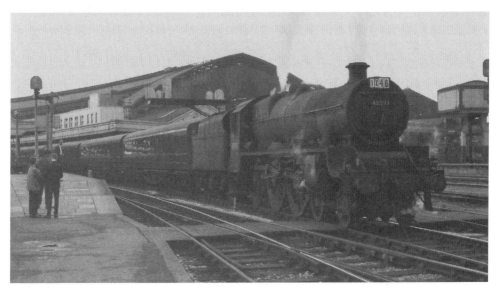

On Friday 29 May 1964, Jubilee No. 45593 *Kolhapur* departs from Platform 6 at Temple Meads with the 1X46 6.18 p.m. Bristol–Oban excursion. Barrow Road had intended this turn to be taken by its last Jubilee, No. 45682 *Trafalgar*, but it had failed at Bath Green Park eleven days earlier and would be withdrawn at the beginning of June. No. 45593 would be the penultimate Jubilee to survive when it was withdrawn from Leeds Holbeck in October 1967 for preservation.

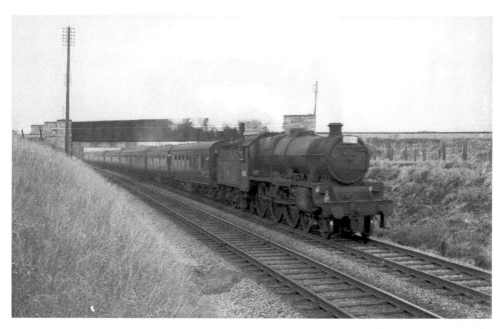

Jubilee No. 45716 *Swiftsure* (with Fowler tender) heads north towards Yate with 1N40 10.20 a.m. Newton Abbot–Bradford on Saturday 18 July 1964. Newly arrived at Holbeck from Newton Heath, No. 45716 would remain in service for only a further two months. This Summer Saturday was something of a swansong for Jubilees in Bristol, with no fewer than eight being noted: Nos 45557/61/93/98, 45602/26/31 and 45716.

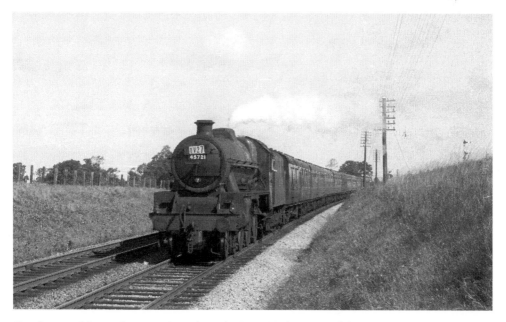

On the penultimate Summer Saturday of 1964, 29 August, Jubilee No. 45721 *Impregnable* hurries from Yate with 1V27 6.40 a.m. Leicester–Paignton (SO). The spur to Stoke Gifford, now used by all trains on the former Midland route, can be seen on the right of the photograph.

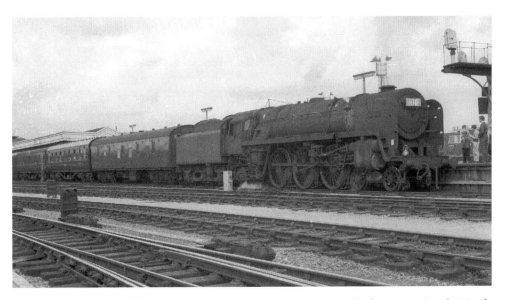

On Saturday 13 June 1964, Britannia No. 70015 *Apollo* arrives at Platform 5 at Temple Meads with the 1X21 relief passenger from Manchester to the South West. Originally allocated to the Western Region, the engine's smoke deflectors had the handrails removed and replaced by cut-out hand grips after No. 70026 *Polar Star* was involved in a fatal accident at Milton, near Didcot. An inquiry suggested that the handrail had impaired the driver's vision. Only Nos 70015–20/22–29 were altered in this way.

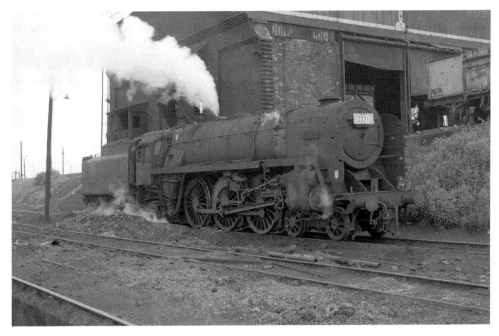

The final day before closure of St Philip's Marsh on Saturday 13 June 1964 produces Britannia No. 70015 *Apollo*, here seen under the coaling stage after its arrival in Bristol shown in the previous picture.

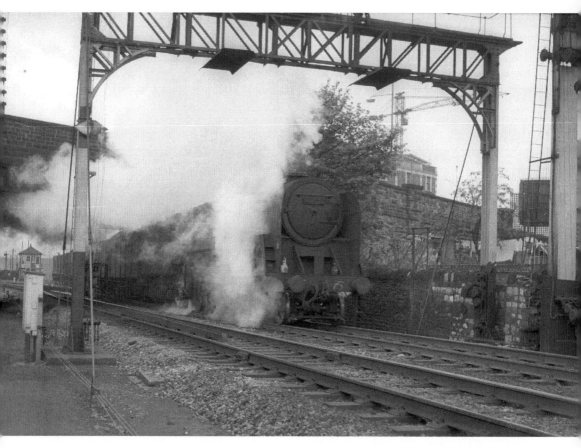

9F No. 92125 lifts the lightly loaded 4N18 2.55 p.m. St Philip's Yard to York Dringhouses onto Fishponds Bank on Monday 11 May 1964. Although officially dieselised in November 1961, this train was still occasionally steam hauled to the end of steam in Bristol in 1965. Lawrence Hill Junction signal box, which controlled the Barrow Road shed roads to the left and St Philip's Yard to the right, can be seen through the road bridge. (Patrick O'Brien)

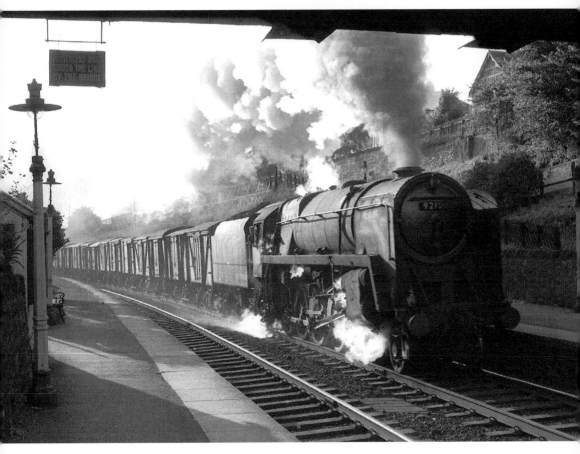

Pounding through Staple Hill on Friday 18 September 1964, 9F No. 92150 deputises for a Peak diesel on 5M25 5.20 p.m. St Philip's Yard–Water Orton.

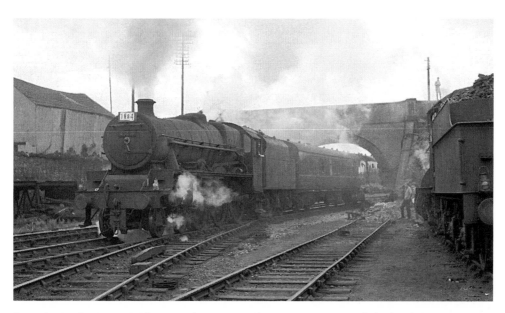

Storming under Day's Bridge past the engine sidings at Barrow Road shed, Jubilee No. 45631 *Tanganyika* (six weeks from withdrawal) prepares to tackle Fishponds Bank with 1N84 2.15 p.m. Bristol–York on Saturday 11 July 1964. Two enthusiasts watch from ground level, but one stands precariously on the wall at the back of the shed.

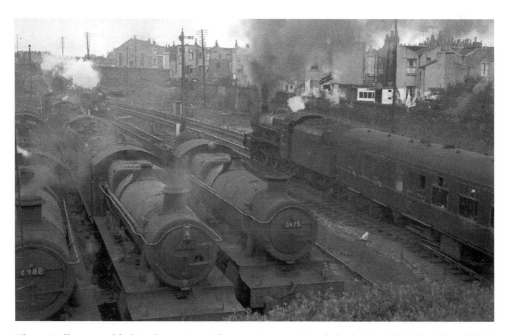

Three Halls are stabled in the engine sidings at Barrow Road shed, Nos 6988 *Swithland Hall*, 4989 *Bulwell Hall* and 5975 *Winslow Hall* (82E), as Saltley Jubilee No. 45674 *Duncan* storms past with 1N84 2.15 p.m. Bristol–York on Saturday 4 July 1964. In the background, No. 5063 *Earl Baldwin* waits to move off to St Philip's Marsh to take over 1M35 11.05 a.m. Ilfracombe–Wolverhampton. Note the lower quadrant signal on this Midland main line.

On Saturday 22 August 1964, Black Five No. 45280 passes Barrow Road on 1N84 2.15 p.m. Bristol–York. On the wall alongside the main line are the inevitable spotters, watching the procession of Summer Saturday extra trains. Parts of this wall are still in existence. (Patrick O'Brien)

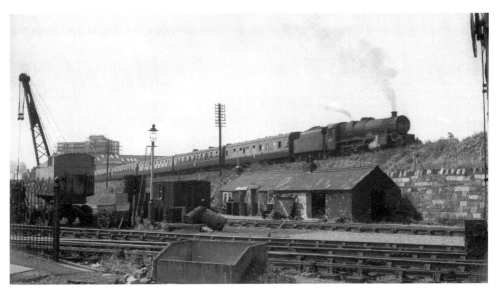

Leeds Holbeck Jubilee No. 45602 *British Honduras* lifts 1N40 10.20 a.m. Newton Abbot–Bradford up Fishponds Bank at Lawrence Hill on Saturday 22 August 1964. The smoke at the rear of the train suggests it is being banked up the incline by No. 73001, the banker on this day. The gradient 1 in 57 can be clearly seen in the photo, which then eased to 1 in 69. The foreground is of interest, showing what appears to be a mobile crane, various store buildings and drums.

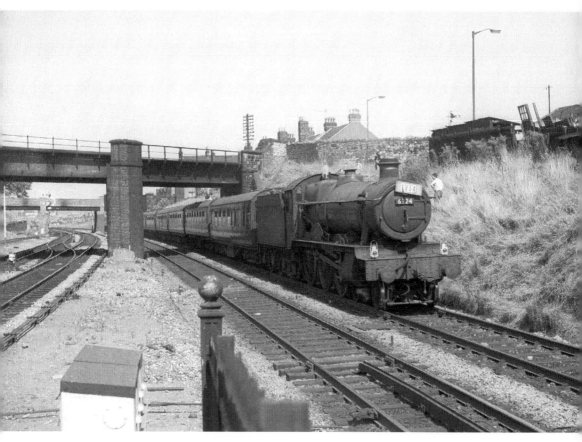

No. 6924 *Grantley Hall* drifts through Lawrence Hill station with 1V54 10.05 a.m. Wolverhampton–Kingswear on Saturday 22 August 1964. The bridge above the train carried the Midland main line to the north. This train did not call at Bristol Temple Meads, but changed engines on the avoiding line at St Philip's Marsh, an occasional practice on Summer Saturdays.

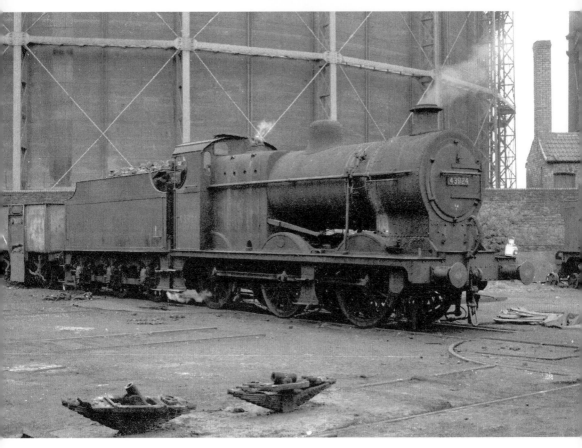

Midland 4F No. 43924 (82E) is stabled at the back of Barrow Road shed on Saturday 23 May 1964. Withdrawn in June 1965, No. 43924 became the first loco to be rescued from Barry scrapyard and is currently in use on the Keighley & Worth Valley Railway. Clearly seen in the photo is one of the two gas holders, both of which were well-known landmarks in the area until they were dismantled in the 1980s. The perimeter wall of the shed can also be seen, which remains the only part of the shed extant today.

On Saturday 19 September 1964, 4F No. 44214 leaves Platform 12 at Bristol Temple Meads with 2M74 6.30 p.m. stopping train to Birmingham. Although this train had been officially dieselised for some three years, it was still frequently steam hauled, but it was unusual to have a 4F on this duty at this late date.

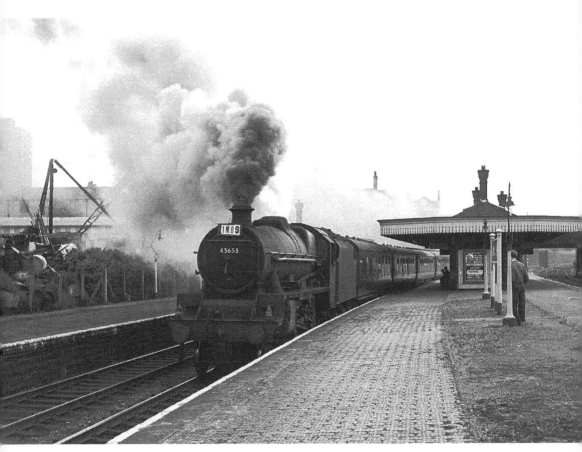

Although officially allocated to Blackpool at this date, Jubilee No. 45653 *Barham* is probably still working off Saltley (2E) and, on Saturday 11 July 1964, storms through Lawrence Hill in preparation for tackling Filton Bank with 1M09 10.44 a.m. Bournemouth West–Nottingham. A remnant of the through trains on the Somerset & Dorset route, discontinued after 1962, the train ran via Southampton and Salisbury with the engine change timed at 2.27 p.m. at Day's Junction.

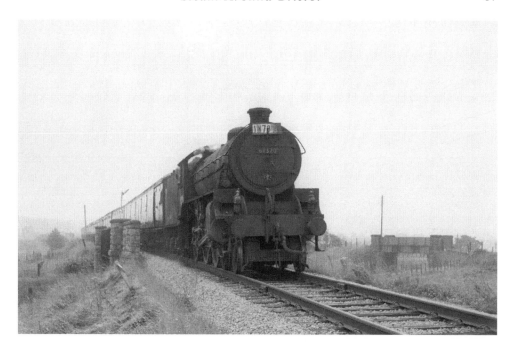

Canklow B1 No. 61370 crosses the Midland main line, which it will soon join, at Yate on the 1N79 7.50 a.m. Paignton–Newcastle on Saturday 18 July 1964. This train avoided Temple Meads and changed engines at St Philip's Marsh, proceeding via Filton and Stoke Gifford to Yate.

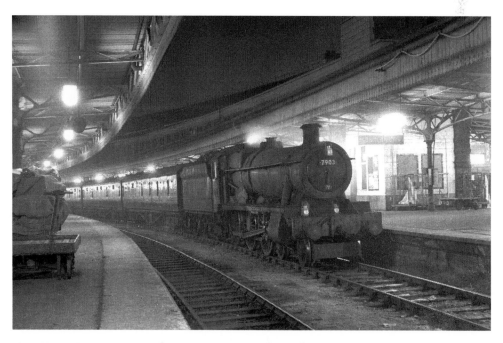

New Year's Day in 1964 and No. 7903 *Foremarke Hall* has arrived at Platform 6 at Bristol Temple Meads with 2B96 5.15 p.m. Weston–Bristol. No. 7903 was withdrawn from Cardiff in June 1964, sold to Barry scrapyard and subsequently rescued and restored.

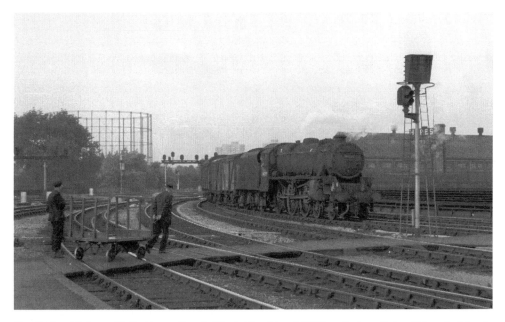

On Friday 19 June 1964, Crewe South Black Five No. 44759 pulls into Bristol Temple Meads with 3V20 1.32 p.m. Derby–Bristol parcels. Pulling trolleys, such as the Post Office variety here, over boarded tracks was commonplace at the time.

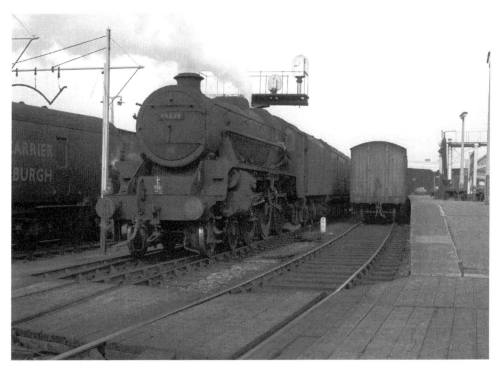

Black Five No. 44839 shunts parcels in Platform 11, the parcels bay at Bristol Temple Meads in August 1964.

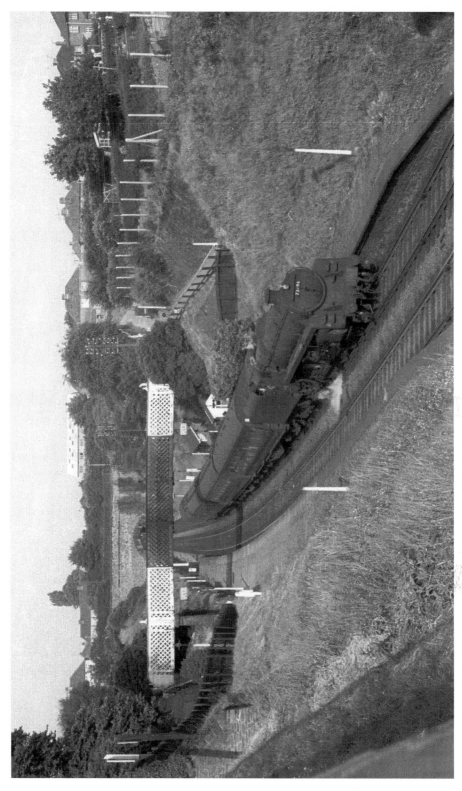

In July 1964, Standard Class 5 No. 73096, allocated to Gloucester (Horton Road), poses in an overall view of Staple Hill station before completing the last stage of its journey on a local train from Gloucester to Bristol.

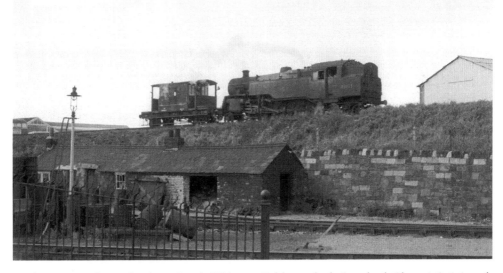

In the course of transfer from South Wales to Feltham shed, Standard Class 4 2-6-4 tank No. 80133 was used by Barrow Road Shed on T807 1.15 p.m. Shed–Westerleigh Yard, conveying workers for the afternoon shift on Saturday 22 August 1964. Accommodation was a single brake van. The engine had earlier arrived on a local train from Gloucester.

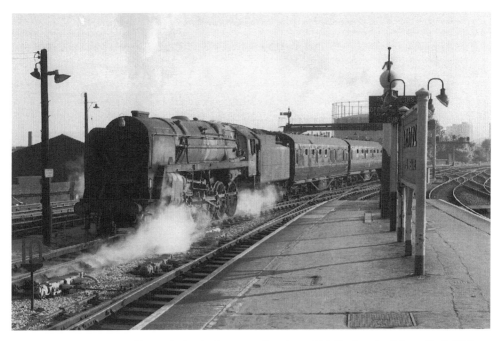

The steam locomotive allocated the highest number, No. 92250, fitted with a Giesl Oblong Ejector, propels the empty stock of 2B74 7.30 a.m. Gloucester–Temple Meads to Barrow Road carriage sidings. The train was generally hauled by a Gloucester Standard Class 5 4-6-0 and the appearance of a Standard 9F 2-10-0 was highly unusual.

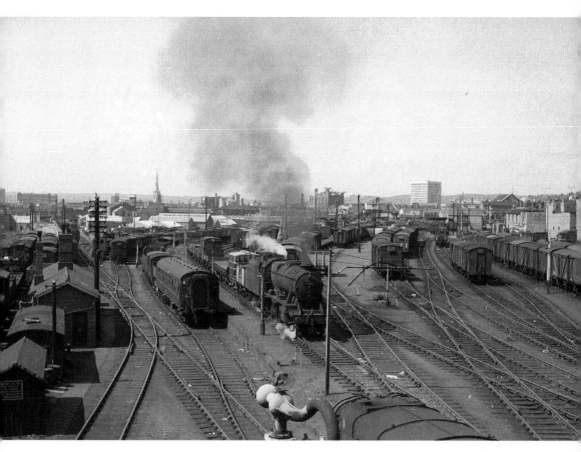

Stanier 8F 2-8-0 No. 48095 departs from St Philip's Yard with 8M49 11.15 a.m. to Washwood Heath on Monday 13 July 1964. The line down to Avonside Wharf can be seen on the left and the site of the old St Philip's station on the right. The yard was run down over a period of years before final closure in 1967. One track remains serving a waste-disposal plant, which has now closed. (Patrick O'Brien)

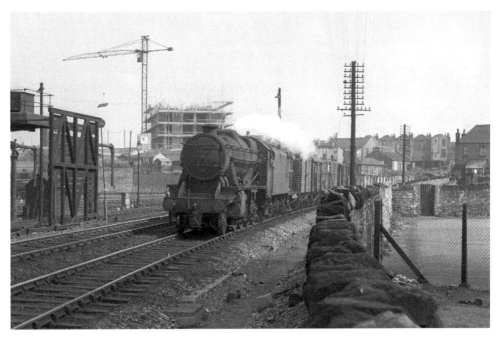

On Monday 13 July 1964, Stanier 8F No. 48651 drifts past Barrow Road shed with T814 7.10 a.m. Westerleigh–West Depot transfer freight, a fill-in duty before it went north the same day on 5M27 7.00 p.m. St Philip's Yard–Derby. The high-rise flats in the background would take another year to complete. (Patrick O'Brien)

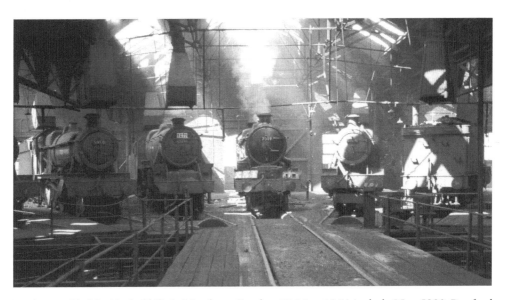

Engines stabled inside St Philip's Marsh on Sunday 17 May 1964 include Nos 5990 *Dorford Hall*, 45298, 7019 *Fowey Castle* and 6984 *Owsden Hall*. Nos 45298 and 7019 had arrived in Bristol on relief trains to the West Country from Birmingham and Wolverhampton respectively. No. 6984 would be allocated to Barrow Road in 1965 and eventually rescued from Barry scrapyard.

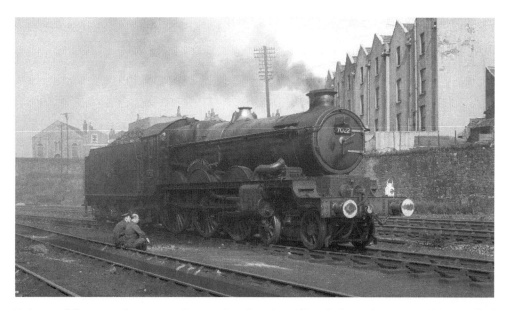

Driver and fireman take a rest at Barrow Road engine sidings before taking No. 7022 *Hereford Castle* light engine to Weston to work 2B25 6.50 p.m. Weston–Swindon on Thursday 27 August 1964. (Patrick O'Brien)

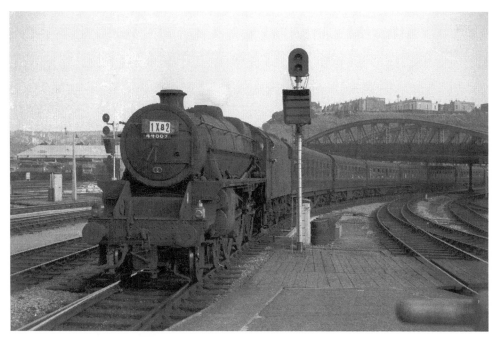

Rare Northampton Black Five No. 44869, which had earlier worked a day excursion from Birmingham to Weston (1X02) on Friday 26 June 1964, pulls into Platform 9 at Bristol Temple Meads with the return working. It was commonplace for both Midland and Eastern engines to work through to the Somerset resort, rather than change engines at Bristol. On the left can be seen the array of diesel power on Bath Road shed.

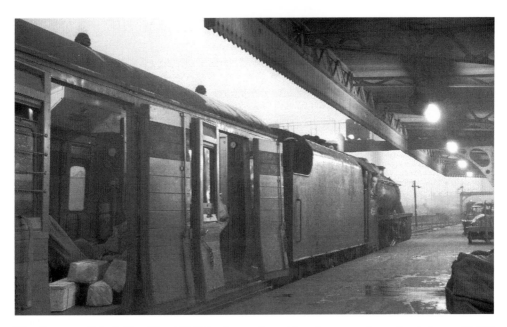

The fireman of Black Five No. 45369 looks out from his cab as parcels are loaded onto 2M74 6.30 p.m. Bristol–Birmingham stopping train on Thursday 12 March 1964. Although dieselised in 1961, the train was frequently steam hauled into 1965.

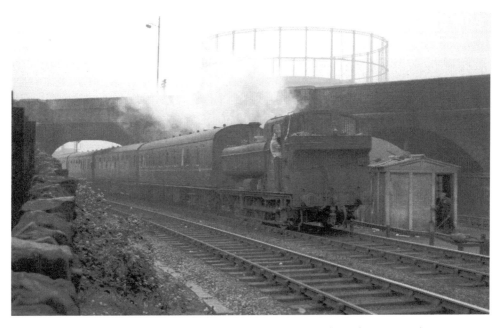

Pannier Tank No. 4689 (82E) heads the 4.52 p.m. Temple Meads–Bath Green Park past Barrow Road on Saturday 5 September 1964, the final day of the summer timetable. Returning on the 5.55 p.m. from Bath, it formed 2B95 6.45 p.m. Temple Meads–Portishead and the 7.30 p.m. return, the last passenger trains before closure. Officially rostered for Standard No. 73003, the Pannier Tank was substituted to mark the event. (Patrick O'Brien)

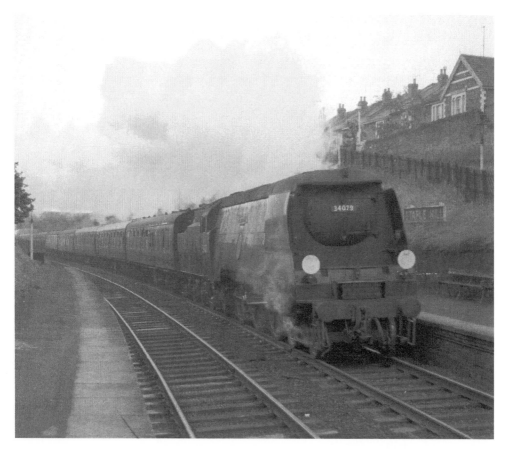

A return Bristol–Portishead ticket purchased on the final day, Saturday 5 September 1964.

Staple Hill is the location for Battle of Britain light Pacific No. 34079 *141 Squadron* on Sunday 14 June 1964 with a Warwickshire Railway Society railtour from Bristol to Derby and Crewe. Having returned to Bristol, it was under repair at Barrow Road shed for much of the following week, but had gone by Friday 19 June. This was the week from which all remaining steam in the Bristol area was serviced at Barrow Road and repairs to a Southern Pacific were probably not welcome.

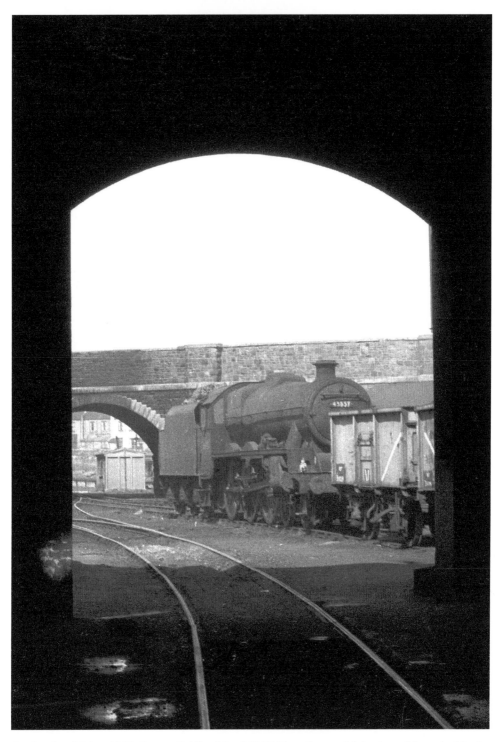

On Sunday 3 May 1964, Burton Jubilee No. 45557 *New Brunswick* is viewed from inside the roundhouse at Barrow Road. The engine had worked in the previous day on 1V28 3.00 a.m. Leeds–Bristol.

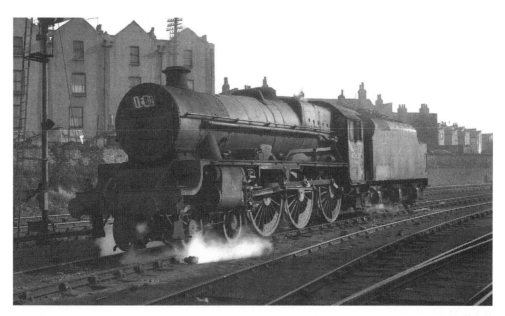

Standing on the exit road at Barrow Road, Holbeck, Jubilee No. 45608 *Gibraltar* waits to move off to Temple Meads to take over a relief Cornishman 1E62 4.27 p.m. to Sheffield on Saturday 3 October 1964. The four-storey houses on the left were on Digby Street and ideally placed for enthusiasts, but not the population at large. The engine has received yellow cab stripes to indicate it was prohibited from working under electrified wires south of Crewe. By this date, Jubilees were comparatively rare in Bristol, with Holbeck examples being the main visitors.

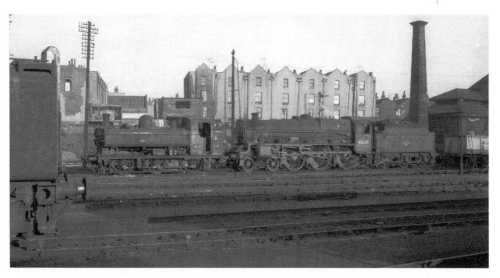

Stabled at the front of Barrow Road is Holbeck Jubilee No. 45697 *Achilles* (with Fowler tender) on Tuesday 5 May 1964. The engine had arrived on 4V42 7.15 p.m. Bradford–Westerleigh and was then used as the diesel standby. It left the following morning on the 1E64 8.40 a.m. Bristol–Sheffield. No. 45697 was one of the last three Jubilees to survive, being withdrawn in September 1967. The chimney behind the engine is the sand drier. Pannier Tank No. 3643 (82E) is keeping the Jubilee company.

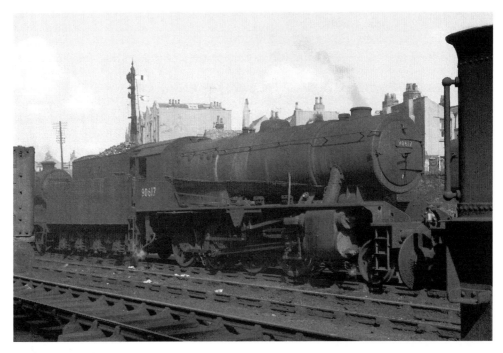

Rare in Bristol, Normanton WD No. 90617 is stabled in the sidings at Bristol Barrow Road on Sunday 3 May 1964. It left the following day on 7M33 6.25 p.m. Avonmouth–Washwood Heath.

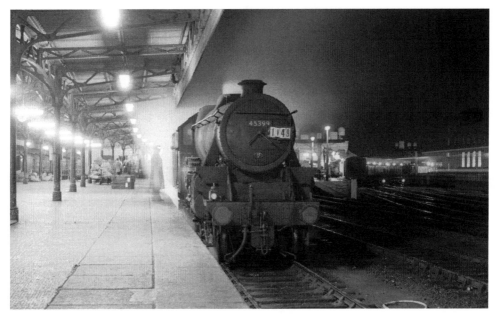

A rare visitor to Bristol, although few would have been around to see it – Carnforth Black Five No. 45399 has arrived at Platform 4 on Saturday 8 August 1964 on the 1V49 7.30 p.m. (FO) Sheffield–Newquay, due in at 00.14 a.m. The authors conducted an overnight vigil on Temple Meads that night.

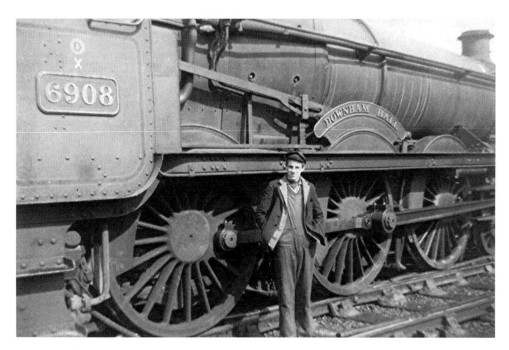

Barrow Road fireman John Clark stands alongside No. 6908 *Downham Hall* at the shed in 1964. Many of the railway workers were made redundant on the closure of Barrow Road; however, some transferred to Bath Road and had a long career on the railways, while others relocated to areas of the country, where steam still had a working life of three years. (John Clark Collection)

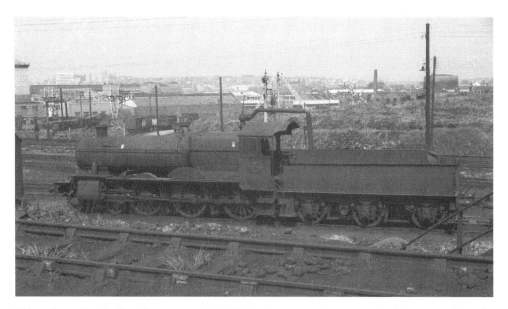

Taken from the Coaling Stage ramp, No. 7817 *Garsington Manor* at St Philip's Marsh in the spring of 1964. In the left background can be seen the Temple Meads train shed and the Post Office building.

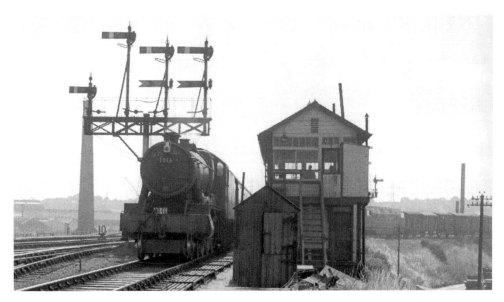

No. 1013 *County of Dorset* passes North Somerset Junction signal box with 2B46 8.45 a.m. Swindon–Weston-Super-Mare (Locking Road) on Monday 13 July 1964. Locking Road was an excursion station, which only received timetabled trains during the summer months and closed at the end of 1964 summer season. This train only ran on weekdays during the holiday period; 1964 was its final year with steam haulage. No. 1013 was withdrawn from service later the same month. The Warship diesel on the right of the picture is waiting for the road out from the Temple Meads avoiding line past St Philip's Marsh. Access to the North Somerset line was also gained from the avoiding line. (Patrick O'Brien)

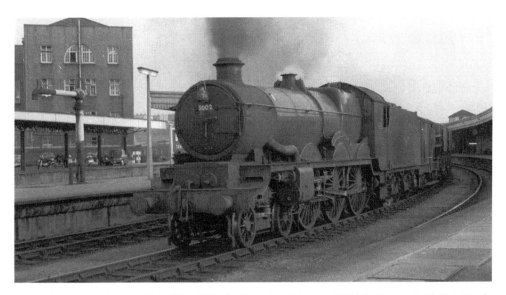

On Wednesday 19 August 1964, No. 5002 *Ludlow Castle* heads 5O21 8.00 p.m. St Philip's Yard–Hoo Junction cement train. The train originated at Avonside and moved onto Fishponds Bank before reversing into Temple Meads. This was one of No. 5002's final duties, as it was withdrawn early the following month. Note the water column, already taken out of use, on Platform 1.

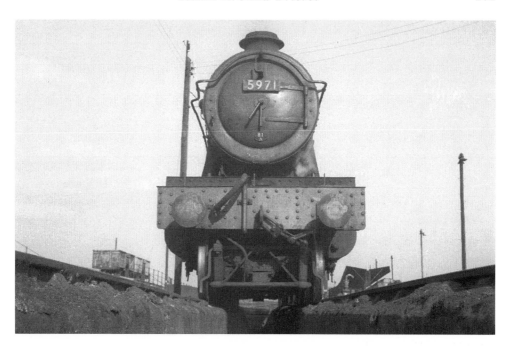

Viewed from a pit at St Philip's Marsh Shed (82B) on Sunday 8 March 1964, No. 5971 *Merevale Hall* waits to be serviced. The diesel multiple unit refuelling facilities can be seen on the right. No. 5971 survived to be the last 59xx series Hall and was withdrawn in December 1965.

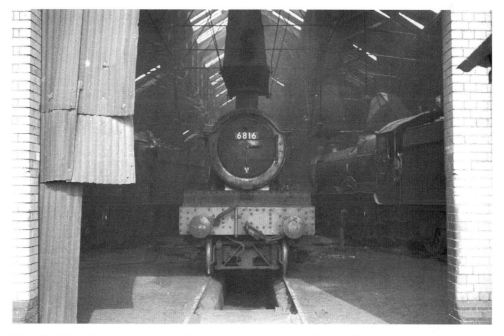

No. 6816 *Frankton Grange* is stabled at the rear of one of the roundhouses at St Philip's Marsh on Friday 24 April 1964, some eight weeks before the shed closed and its allocation, including this engine, transferred to Barrow Road.

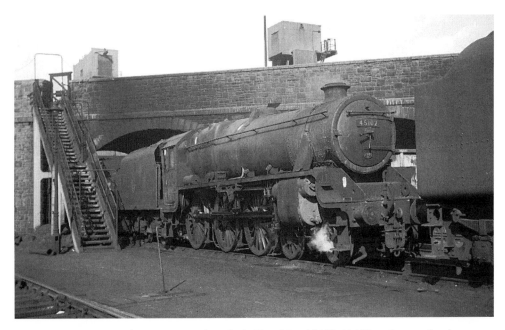

On Sunday 13 September 1964, Derby Black Five No. 45102 (16C) waits on the departure road at Barrow Road shed. The steps were the official entrance into the shed, but many took advantage of the low wall on Day's Road at the back of the shed to achieve illicit entry. Barrow Road frequently had to provide engines to work banana trains from Avonmouth. No. 45102 was rostered for the 4M37 3.15 p.m. Avonmouth–Crewe on this date.

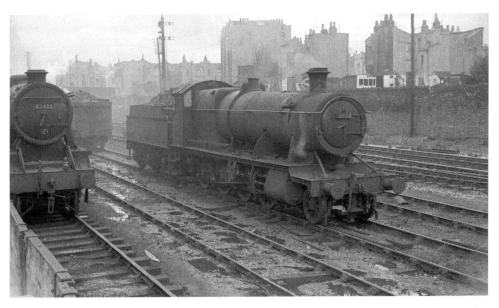

On Saturday 11 July 1964, Churchward 2-8-0 No. 2822, allocated to Taunton, rests in the sidings at Barrow Road shed. Built in January 1907 at Swindon, No. 2822 would have a working life of nearly fifty-eight years. The engine was allocated to Barrow Road in October 1964 and withdrawn a month later.

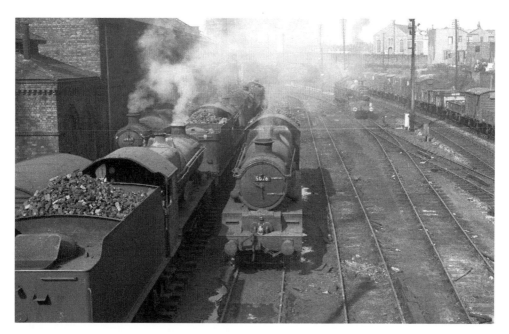

Barrow Road has lost its distinctive Midland flavour in this photograph of the engine sidings on Thursday 27 August 1964. No. 7022 *Hereford Castle* will work light engine to Weston to return on 2B25 6.50 p.m. Weston–Swindon, the penultimate day of steam working on this train. No. 5076 *Gladiator* was rostered for 5F09 6.52 p.m. Avonmouth–Llandilo, while No. 5042 *Winchester Castle* will work 4H60 9.30 p.m. Temple Meads–Worcester and No. 6932 *Burwarton Hall* 4F13 11.48 p.m. Temple Meads–Swansea. (Patrick O'Brien)

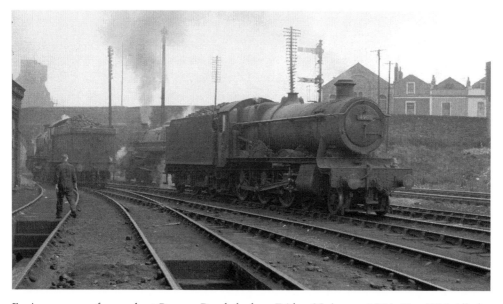

Engines prepare for work at Barrow Road shed on Friday 28 August 1964. No. 4985 *Allesley Hall* from Neath shed will later work 4F13 11.48 p.m. Temple Meads–Swansea, while No. 73015 waits to move light engine to Temple Meads for 5E09 6.40 p.m. to Swanbourne. (Patrick O'Brien)

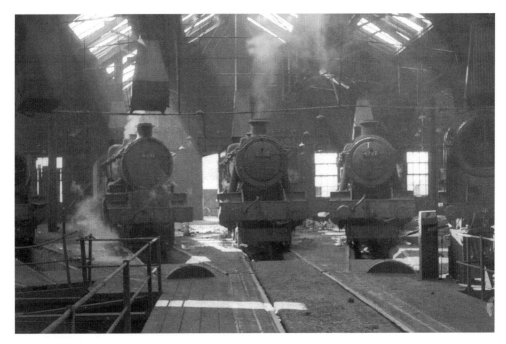

Stabled inside one of the roundhouses at St Philip's Marsh (82B), on Sunday 3 May 1964, are Nos 4093 *Dunster Castle* (82B), 6997 *Bryn-Ivor Hall* (82B) and 6998 *Burton Agnes Hall* of Old Oak Common (later to be preserved). Together with No. 7003 *Elmley Castle*, No. 4093 was one of the last two Castles to be allocated to St Philip's Marsh. The shed would close seven weeks after this photograph and its allocation moved to Bristol Barrow Road (82E).

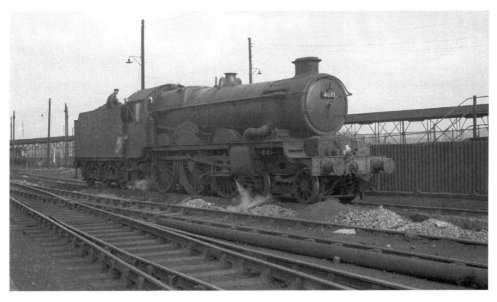

No. 4093 *Dunster Castle* (82B) is serviced on the ash pits at Bristol St Philip's Marsh on Friday 24 April 1964. The piles of ash are an indication of the unpleasant jobs performed by steam shed staff. Behind the loco is the DMU fuelling facility, brought into use in 1959.

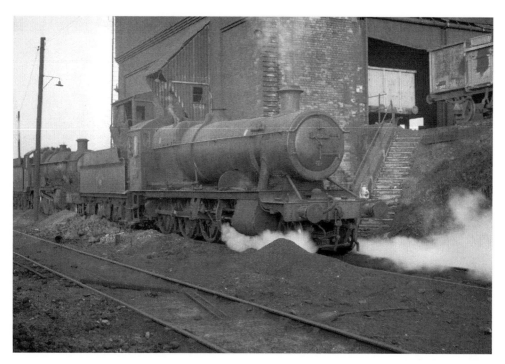

Banbury 2-8-0 No. 3850 stands under the coaling stage at Bristol St Philip's Marsh shed in 1964 in the company of an unidentified Grange. The photo emphasises the rather primitive disposal and coaling facilities at ex-GW sheds, with the coal tubs clearly visible. No. 3850 was withdrawn in 1965 and spent twenty years at Barry before restoration and regular use on West Somerset Railway.

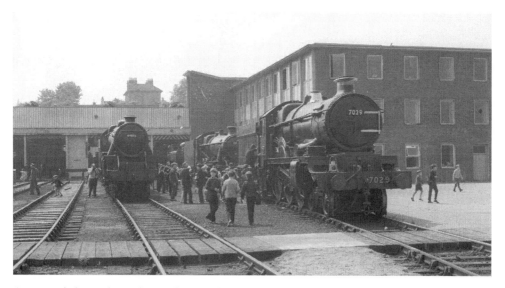

At one of the early Bath Road open days in summer 1965, Nos 7029 *Clun Castle*, 7924 *Thorneycroft Hall*, 44856, 9680 and (not shown) 44264 represent steam traction. This became a regular attraction with steam in later years.

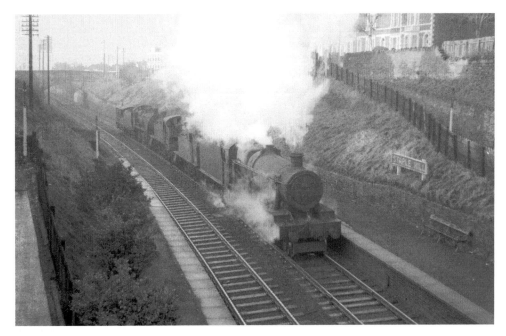

In early January 1965, No. 7925 *Westol Hall* tows Nos 4593, 6118 and 31406, which had been stored at Barrow Road and are en route for scrapping, through Staple Hill.

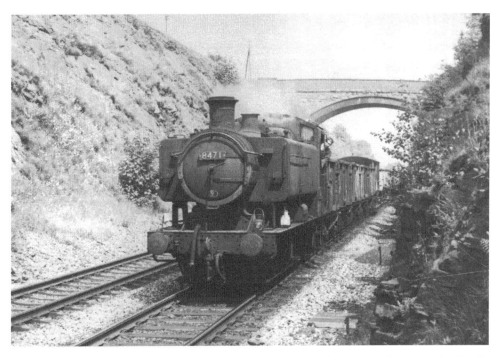

Hawksworth Pannier No. 8471 (82E) heads through Winterbourne with a transfer freight in spring 1965. The last few members of this once-numerous class were allocated to Bristol Barrow Road in 1965, from where they were all withdrawn.

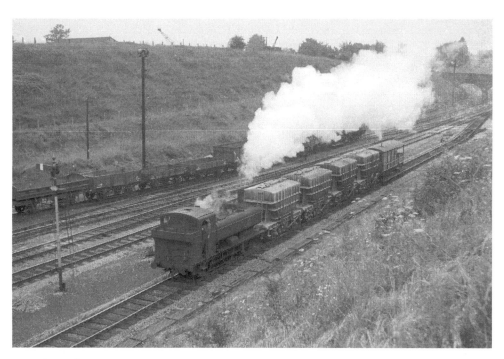

At Stoke Gifford, Pannier Tank No. 9711 (82E) can be seen entering the yard with a short train of four cement presflos on Saturday 3 July 1965.

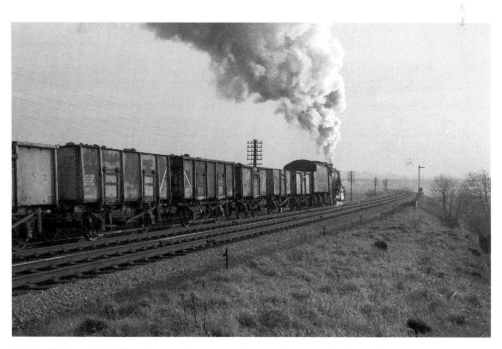

Derby 8F No. 48362 heads a coal train south towards Westerleigh Yard on 24 January 1965. This section, south of Yate South Junction, closed as a through route to Bristol via Mangotsfield in 1970, the stub to Westerleigh being retained to serve an oil terminal.

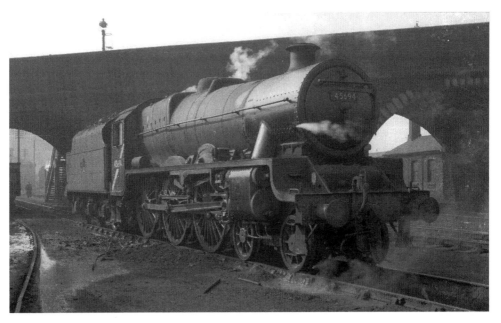

On Sunday 7 March 1965, Wakefield Jubilee No. 45694 *Bellerophon*, complete with yellow stripes on the cab to denote prohibition on electrified lines south of Crewe, waits on the exit road at Barrow Road to go light engine to Gloucester at 2.15 p.m. It finally left the area on the 5E09 6.40 p.m. Temple Meads–Cambridge on Tuesday 9 March 1965.

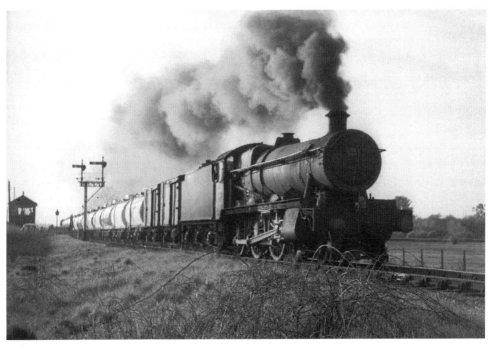

No. 6934 *Beachamwell Hall* climbs from Pilning Low Level towards the main line in May 1965 on 5N12 7.50 p.m. Severn Beach–ICI Wilton (Teesside).

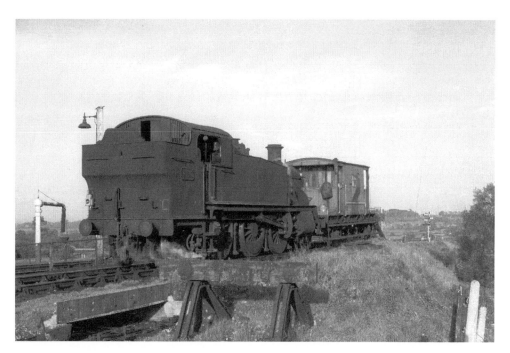

In May 1965 Prairie Tank No. 4115, allocated to Severn Tunnel Junction, is stabled in a siding at Pilning station. Although despatched to Barry for scrapping, No. 4115 is a donor engine to recreate lost members of GWR types that were not preserved. 41xx tanks were regularly employed on the Severn Tunnel car shuttles, which operated between Pilning and Severn Tunnel Junction, enabling motorists to avoid the Aust Ferry or the alternative longer route via Gloucester.

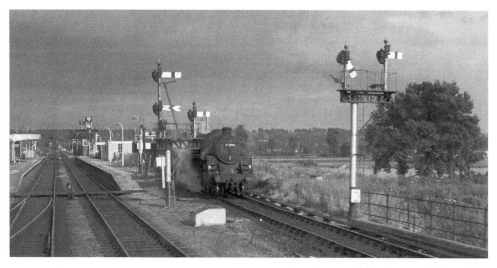

Once common in the Bristol area, but now allocated to Croes Newydd, Standard Class 5 No. 73096 has the road at Pilning station with a freight through the Severn Tunnel to South Wales in July 1965. Eventually withdrawn from Patricroft (9H) at the end of 1967, No. 73096 was sold to Barry scrapyard and later preserved.

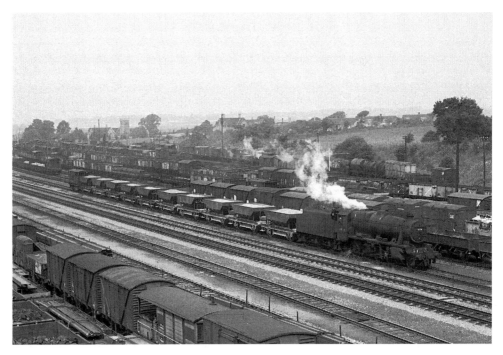

Stanier 8F No. 48128 pulls into the extensive yard at Stoke Gifford with a ballast train on Saturday 3 July 1965. Bristol Parkway station now occupies the site of the former marshalling yard. The church at Stoke Gifford village is clearly visible.

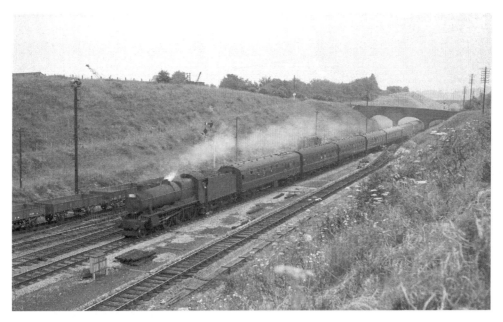

No. 7912 *Little Linford Hall* passes through Stoke Gifford on Saturday 3 July 1965 with 1V52 6.55 a.m. Wolverhampton–Penzance. It would return north from Bristol on 1M35 11.10 a.m. Ilfracombe–Wolverhampton.

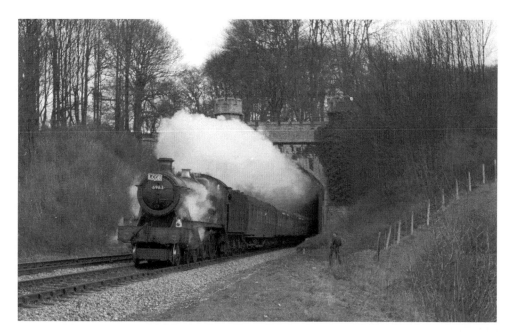

Heading the LCGB "Wessex Downsman (1)", No. 6963 *Throwley Hall* emerges at speed from Twerton Tunnel, near Bath, on Sunday 4 April 1965. The train ran from Waterloo, travelling to Reading and via Devizes and Bradford-on-Avon to Bath and Bristol. It then returned to Bath Green Park and Bournemouth West to Waterloo. The tour was repeated a month later, by which time No. 6963 had lost its front numberplate.

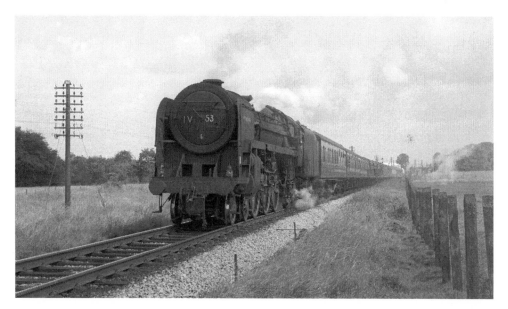

On Saturday 26 June 1965, Britannia No. 70045 *Lord Rowallan*, now minus its nameplate, heads the 1V53 8.00 Wolverhampton–Ilfracombe train near Yate. Britannias had been allocated to Oxley Shed to work these services for the Summer Saturday 1965 season and would be the last scheduled express trains in Bristol diagrammed for steam haulage.

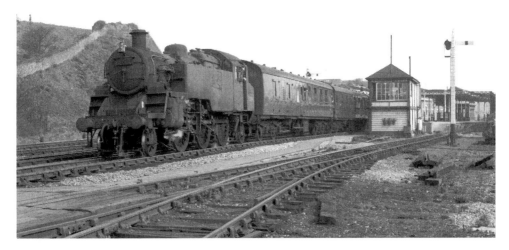

Standard 3 Tank No. 82004 pulls away from Mangotsfield Station with a local from Bath Green Park to Bristol Temple Meads in late 1965. It has received the name "*Midford Castle*" scrawled in the dirt on the tank side. Together with No. 82041, it regularly worked local trains to Bristol and was withdrawn in October 1965.

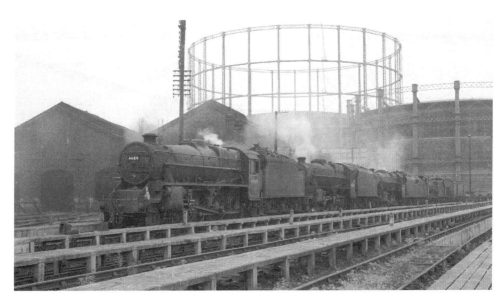

On Sunday May 30, 1965, Black Fives Nos 44819, 44989 and 45272 are lined up on Barrow Road Shed ready to depart on special freights to the North. No. 44819 had arrived at Bristol Temple Meads the previous evening on 1V46 4.55 p.m. Sheffield–Bristol train, towing failed Peak D39. Two stored 4Fs can be seen at the end of the row. These sidings were originally used for stabling carriage stock, the raised platforms used by cleaners, but in March 1965 stock for northbound trains was kept at Malago Vale sidings adjacent to the Western main line to the west.

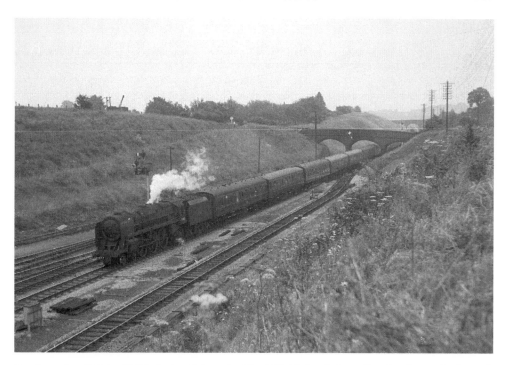

On Saturday 3 July 1965, Oxley Britannia No. 70045 *Lord Rowallan* heads south through Stoke Gifford on 1V53 8.00 a.m. Wolverhampton–Ilfracombe. Three Britannias were allocated to Oxley Shed for summer 1965 to work this and other trains to Bristol from Wolverhampton, the only expresses rostered for steam in Bristol.

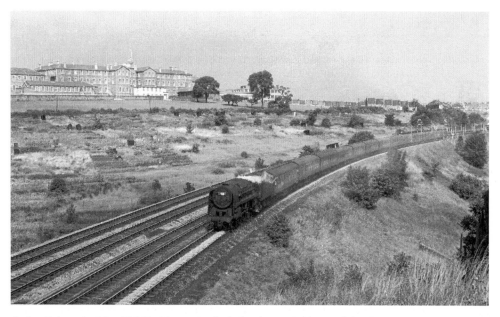

Oxley Britannia No. 70053 *Moray Firth* drifts down Ashley Hill bank with 1V53 8.00 a.m. Wolverhampton–Ilfracombe on Saturday 14 August 1965.

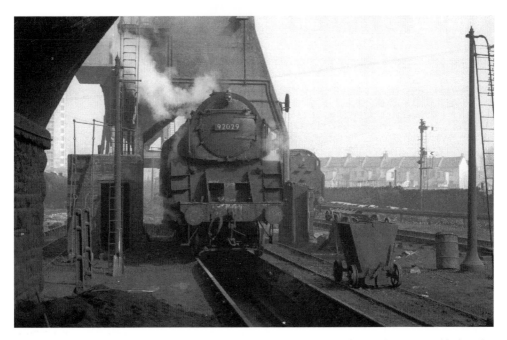

Ex-Crosti-boilered 9F No. 92029, allocated to Saltley, has been coaled and is now stabled under the ash plant at Bristol Barrow on Sunday 7 March 1965.

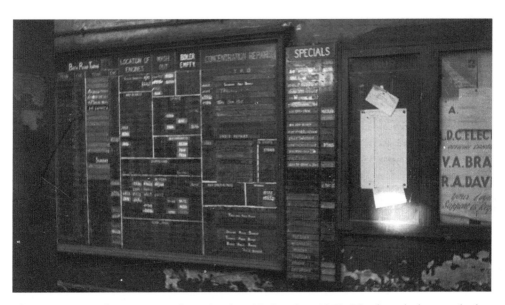

The Barrow Road Roster Board on Sunday 10 October 1965. The board shows whether engines are in steam, under repair, away balanced, withdrawn, etc. On the extreme right of the board are the remaining twelve steam rosters at the time. For the next day, Standard 3 Tank No. 82001 (82E) is rostered for 2C93 6.00 a.m. Bournemouth West, which it will work as far as Bath, while No. 48381 is down for 4M47 1.00 a.m. Tavistock Junction (Plymouth)–Crewe, which it will take from St Philip's Marsh at 6.20 a.m., and No. 73003 will take out 5E09 6.40 p.m. Temple Meads–Cambridge. (Patrick O'Brien)

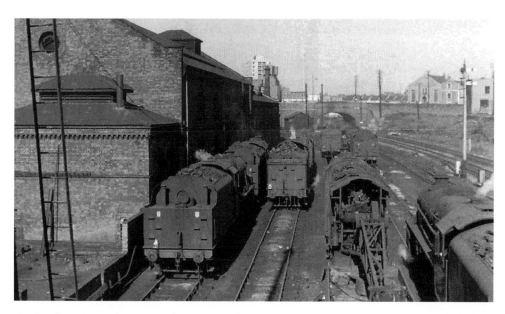

On Sunday 10 October 1965, the engine sidings at Barrow Road stable nine engines in steam, giving little indication of the shed's closure in six weeks' time. From the left are Nos 48671, 48460, 6930 *Aldersey Hall*, 48687, 73003, 4920 *Dumbleton Hall* (82E), 44812, 45264, 6876 *Kingsland Grange* and a crane. (Patrick O'Brien)

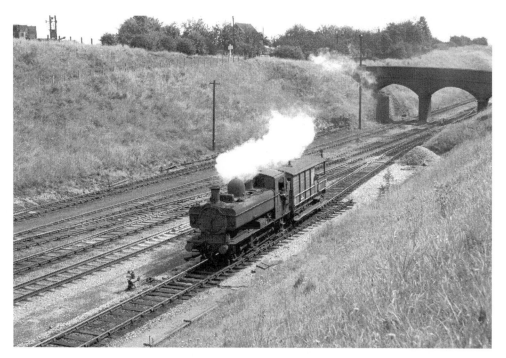

Pannier Tank No. 3659 (82E) hurries into Stoke Gifford Yard on Saturday 24 July 1965. Stoke Gifford took on extra importance after the closure of nearby Westerleigh Yard in October 1964. It too would close in October 1971 and the site would be developed for Bristol Parkway station.

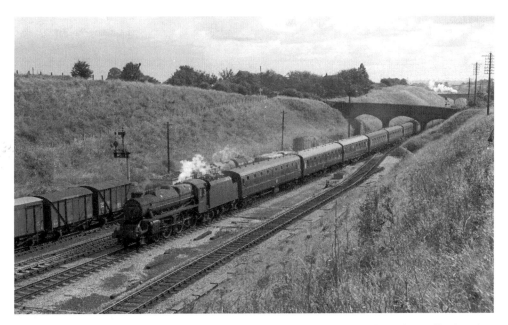

On Saturday 24 July 1965, Black Five No. 44691 heads south through Stoke Gifford with a holiday train from Wolverhampton to the West Country. These were the only express passenger trains rostered for steam in the summer of 1965.

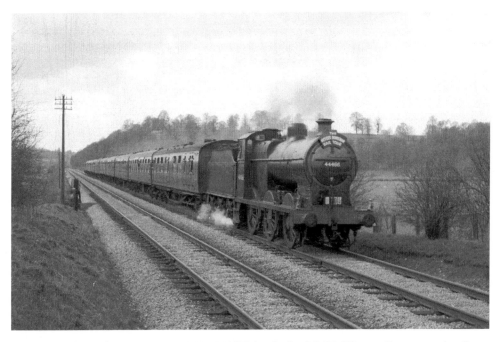

On Sunday 4 April 1965, 4F No. 44466 (82E) hauls the LCGB 'Wessex Downsman' railtour between Kelston and Bath. No. 44466, assisted by Hymek D7007, had taken the train from Temple Meads to Mangotsfield, where No. 44466 continued unaided to Bath Green Park. Despite its excellent external condition, the engine was withdrawn a month later.

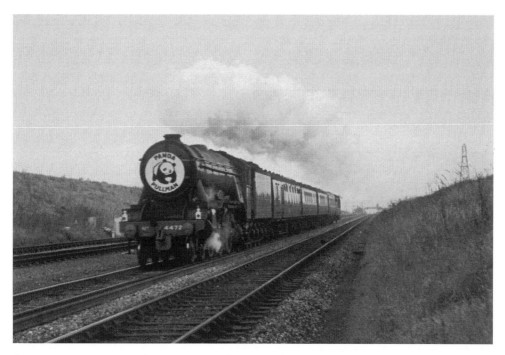

A3 No. 4472 (60103) *Flying Scotsman* hurries a lightweight special, the 'Panda Pullman', through Pilning on its way to South Wales on Saturday 13 November 1965.

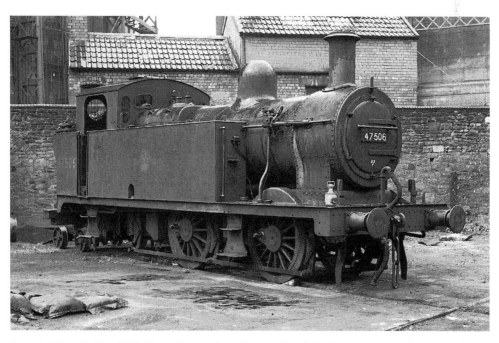

Jinty 0-6-0 tank No. 47506 is under repair at Barrow Road shed in May 1965, having made use of the wheeldrop at the shed. The repair took almost a month before the engine worked light to its home shed, Bath Green Park, on Wednesday 19 May 1965.

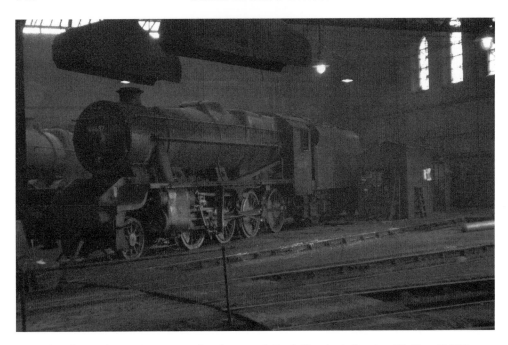

Recently allocated to Leicester on the closure of Coalville shed, Stanier 8F No. 48687 rests inside the roundhouse at Barrow Road on Sunday 3 October 1965. It departed two days later on 6M17 10.15 p.m. East Depot–Banbury. (Patrick O'Brien)

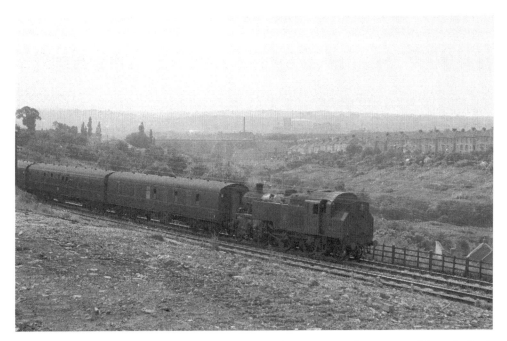

Standard 3 Tank No. 82041 lifts 2C93 15.20 Bristol–Bournemouth West up Fishponds Bank on Saturday 16 October 1965. Visible in the background is the viaduct between Kingswood Junction and Ashley Hill Junction, where the Great Western link to Avonmouth joined.

A single ticket from Temple Meads to Staple
Hill, priced at 10*d.*

A second-class single from Bitton to
Fishponds. Bitton station is now the
headquarters of the Avon Valley Railway.

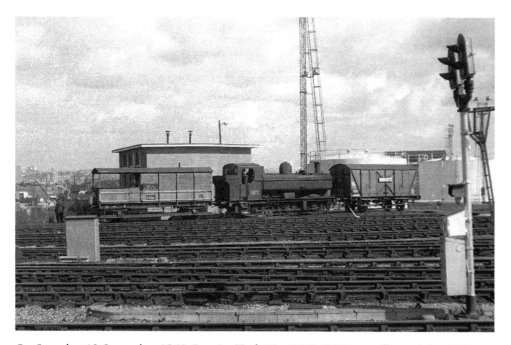

On Saturday 18 September 1965, Pannier Tank No. 9672 (82E) was allocated the 8.15 a.m.
Enparts turn and can be seen entering Bath Road diesel depot with a van of engine parts.
(Patrick O'Brien)

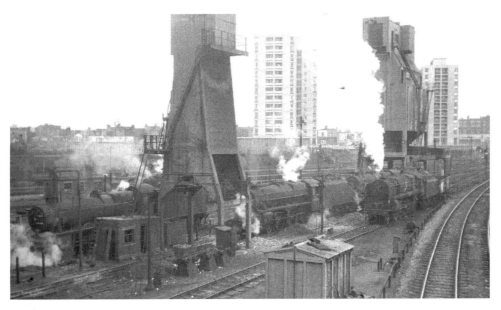

The coaling and ash plants at Bristol Barrow Road host Nos 4920 *Dumbleton Hall* (82E), Oxley Black Five 45264, Leicester 8F 48671 and 92235 (82E) on Saturday 9 October 1965, seven weeks before the closure of the shed. The high-rise flats had recently been completed and the occupants would no doubt have been glad to see the end of steam and the closure of the shed. (Patrick O'Brien)

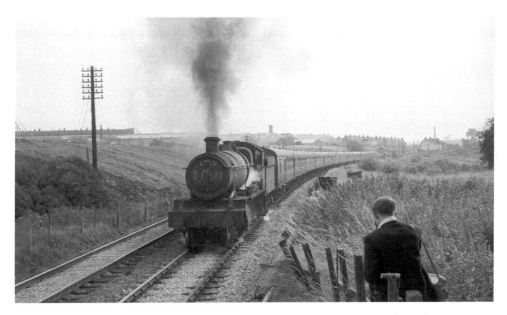

On Saturday 17 July 1965, No. 6803 *Bucklebury Grange* climbs Fishponds Bank near Kingswood Junction with 1M37 11.25 a.m. Newquay–Wolverhampton. The Wolverhampton trains were the only steam-hauled main-line trains into Bristol on Summer Saturdays in 1965 and it was quite rare to see a WR engine at work on them. Motive power was usually Britannias or Black Fives.

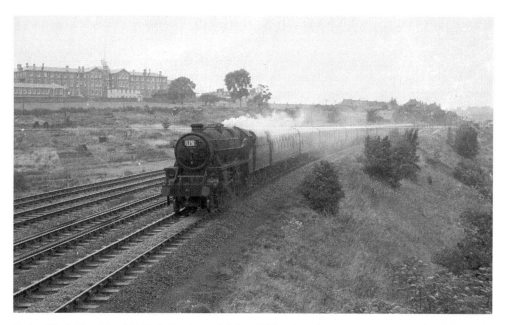

Oxley Black Five No. 45040 drifts down Ashley Hill bank with 1V52 6.55 a.m. Wolverhampton–Penzance on Saturday 21 August 1965. The substantial building in the background is Mullers orphanage, which closed in 1958.

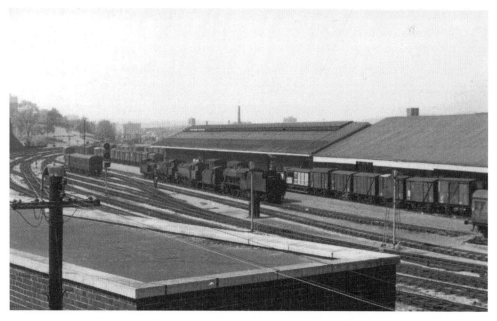

The final five steam engines from the Bristol area await their final journey to the scrapyards of South Wales. At the end of April 1966, Jinties Nos 47506 and 47276 keep company with Standard 4 Tanks Nos 80041/43 and 8F No. 48760 at Pylle Hill goods depot, just outside Bristol Temple Meads. These engines were withdrawn following the closure of the Somerset & Dorset line and Bath Green Park shed the previous month. (Patrick O'Brien)

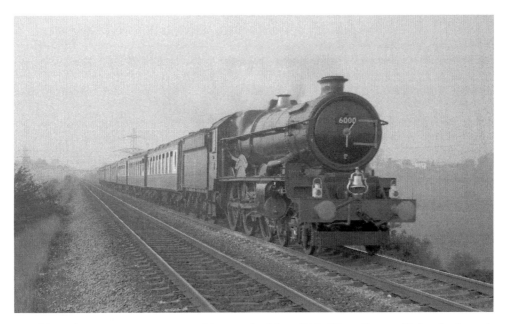

Heralding the return to steam on BR metals, No. 6000 *King George V* heads through Winterbourne on its way to Tyseley with the Bulmer's Special on Saturday 2 October 1971. The success of this trip opened the way for limited future main-line steam-working on selected routes.

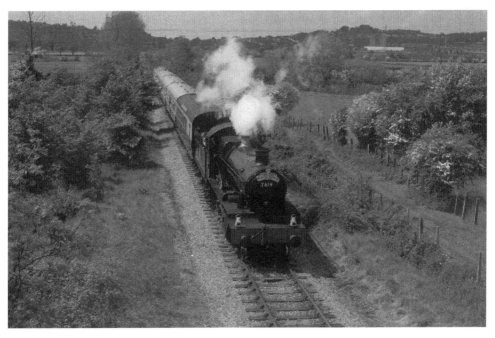

A series of special trains was run in conjunction with 150th anniversary of the GWR. On Saturday 25 May 1985, No. 7819 *Hinton Manor* leaves Portishead with the 'Bristol Evening Post Avon Gorge Special'. The line is currently in the process of being re-opened to passenger traffic.

ROD STEELE

LMS STEAM
AT EUSTON & CAMDEN

LOCO-SPOTTING
IN THE 1950s & 1960s

LMS Steam at Euston & Camden

Rod Steel

Long gone days of steam-hauled express trains of the former London
Midland & Scottish Railway are recaptured.

978 1 4456 3268 1
160 pages, illustrated throughout

SEVENTIES SPOTTING DAYS AROUND THE
WESTERN REGION

KEVIN DERRICK

Seventies Spotting Days Around The Western Region

Kevin Derrick

Kevin Derrick looks back at the locomotive-spotting days of the
1970s in the Western region of England.

978-1-4456-6089-9
96 pages, illustrated throughout